BRITAIN IN OLD PHOTOGRAPHS

BEACONSFIELD

BEACONSFIELD AND DISTRICT HISTORICAL SOCIETY

compiled by

HERBERT CRANE, LESLIE HORROCKS,
ELIZABETH SCOTT-TAGGART,
BETTY THOMPSON & KEITH THOMPSON

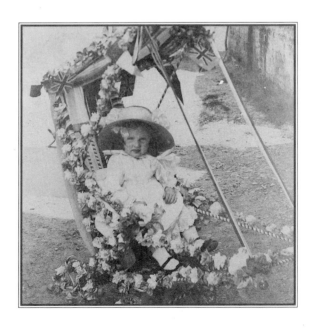

SUTTON PUBLISHING LIMITED

Sutton Publishing Limited
Phoenix Mill · Thrupp · Stroud
Gloucestershire · GL5 2BU

First published 1996

Cover photographs:(front) Beaconsfield
Camera Club *c.* 1900. Left to right: Augustus
Day, Archibald Cheale, Fred Myers, Thomas
Lane, -?-; (back) the latest model Humber seats
the cast of 'The Mikado' in 1910.
Title page photograph: Miss Kathleen Day
now a local author and historian of
Beaconsfield, in her decorated pushchair
in 1911. Not surprisingly, this ensemble
won first prize in a competition.

British Library Cataloguing in Publication Data
A catalogue record for this book is available from the
British Library.

ISBN 0-7509-0930-7

Typeset in 10/12 Perpetua.
Typesetting and origination by
Sutton Publishing Limited.
Printed in Great Britain by
Ebenezer Baylis, Worcester

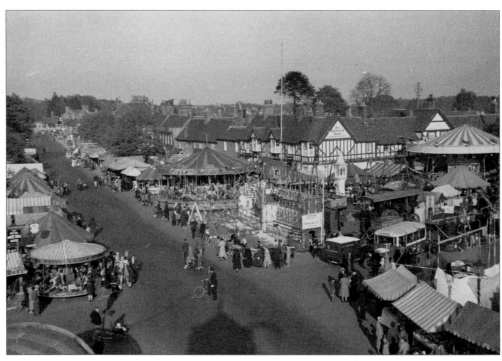

An unusual view of the fair in the 1930s. The photograph seems to have been taken from the top of the
helter-skelter, which casts its shadow in the foreground.

CONTENTS

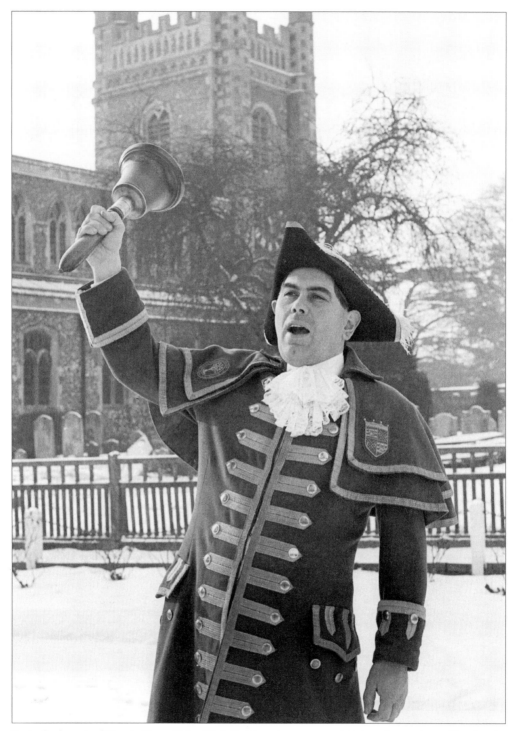

Part of a long tradition is Town Crier Dick Smith, who was appointed to the ancient office by the Manorial Court in 1969 when he was 22. Dick's rich, powerful voice gained him the national championships at Hastings in 1969 and 1970. His bell, cast in 1797, records the names and dates of the town criers from 1862. On special occasions Dick may be heard proclaiming, 'Oyez, oyez, oyez. . . .'

INTRODUCTION

The story of Beaconsfield is of two towns. The Old Town, an ancient settlement at a crossroads, and later a staging post on the coach route between London and Oxford, and the west, was at its most prosperous in the eighteenth and early nineteenth centuries and this is reflected in its buildings. If one looks at maps from the end of the last century, one sees only the four Ends, and beyond lies open country with fields, woods and a few farm buildings. The New Town has grown up entirely in this century round the railway station nearly a mile to the north, and the two have become united. The first syllable of the town's name is always pronounced locally as 'Beck'.

This book begins by showing the Old Town with its wide crossroads and the four Ends, free of traffic and lined with fine old houses. Many of these still have large gateways leading to courtyards which originally housed stables where the horses were kept and changed. The next section shows how many of them were inns and public houses at one time or another. Journeys in the coaching era, besides being extremely uncomfortable, were not without danger. Highwaymen lurked in the wood beside the steep hill from Wooburn Moor to Holtspur, still called Cut-throat Wood.

In the thirteenth century the surrounding area was under the feudal authority of Richard, Earl of Cornwall. In 1255 his brother, King Henry III, granted him a royal charter for a weekly market in his manor of 'Bekenesfeld' to be held on a Tuesday, and in 1269 the King granted a further charter to hold an annual fair. The market and the fair brought good business to the town. The market continued until early in the nineteenth century when it closed, but the remains of the ancient market hall, which survived within the group of buildings known as Day's Stores, were not demolished until 1952. The site has now become a pleasant garden area, with the old stone horse-trough moved from across the road and filled with flowers. The fair, held every year on 10 May, still flourishes, and this is an important date in Beaconsfield's year. The weekly market, held every Tuesday, was revived in 1982.

Three large estates surrounded the Old Town: Hall Barn, Gregories and Wilton Park. Section 3 on Great Houses shows the three stately homes built on those estates, some of the famous people linked with them, and some of the changes that have taken place down the centuries.

The Convalescent Home for children flourished for more than fifty years from 1910, first in London End and later in Station Road. The pictures are from a splendid album compiled by the founders, Miss Hennell and Miss Meates, and show the contribution that Beaconsfield made towards the recovery of poor and sick children from London hospitals.

Section 5, Transport and the Coming of the Railway, shows how cars and buses took over from horse-drawn vehicles, and how the arrival of the railway led to the creation of the New Town. Before Beaconsfield had a railway the nearest station was at Wooburn Green, three miles away, or one could go to Slough. It was not until 1906 that the Great Western and Great Central Railway Companies jointly completed the construction of the line passing to the north of the Old Town. Farmland from the surrounding estates was then sold for development, and a network of roads and building plots was quickly laid out.

From the early years of this century the New Town grew rapidly, and shopping parades were developed. Estate agents extolled Beaconsfield as a healthy and desirable place to live, combining the advantages of country life with a good rail service to London for commuters. More and more residential areas were created, and new schools were built. By 1919 a Council Hall was built in the New Town, but by 1936 this was already too small and was replaced by the present Town Hall. This period of the town's development has been an era of continuing change for an ever-growing community.

Section 7, People at Work, covers a wide range of activities from earlier days, including old trades, farming, and public services. Section 8, Sport and Leisure, has a large selection of pictures ranging from King Edward VII shooting at Hall Barn to cricket and football teams, and from Scouts and Guides to music and amateur theatricals.

Section 9, Wartime, recalls patriotic flag-waving to celebrate victories in the Boer War; tragic refugees from Belgium in the First World War; sand-bagging, Civil Defence and Home Guard, and the provision of a convalescent home for the Free French during the Second World War. A sombre reminder of the fearful loss of life in both wars is the perpetual flame in the war memorial near the parish church in the Old Town.

To complete the book, a section has been included with some interesting and perhaps unfamiliar early photographs of the areas around Beaconsfield.

It is fortunate for Beaconsfield as a whole that the New Town with its modern residential and shopping developments has had the space to grow separately from the Old Town. There the broad four Ends, flanked with attractive old buildings, have been designated a Conservation Area, so enabling this part of the town's old-world character and charm to be retained, and a sense of history to be preserved.

THE OLD TOWN

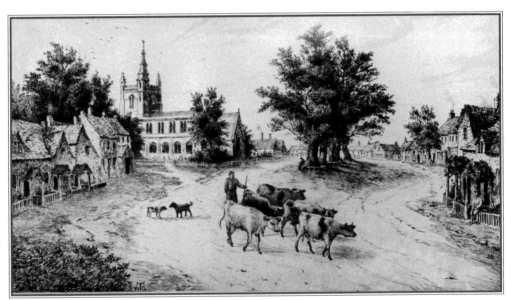

This charming old print of the parish church and great trees in Windsor End cannot be dated earlier than 1884 because the pinnacles on the church tower were added at that date, although the rustic scene makes the print look earlier.

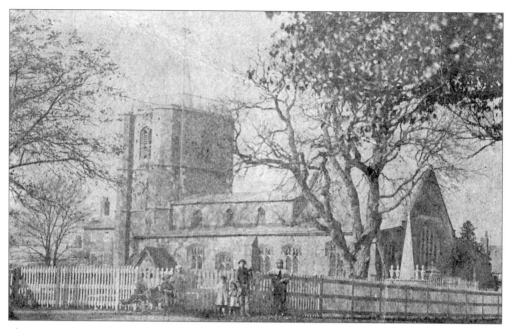

This very early photograph shows the church as it existed before 1869 and as it appears in many old prints. On the right is the pale spire of Waller's tomb and the walnut tree that was planted at the time of his burial in 1687.

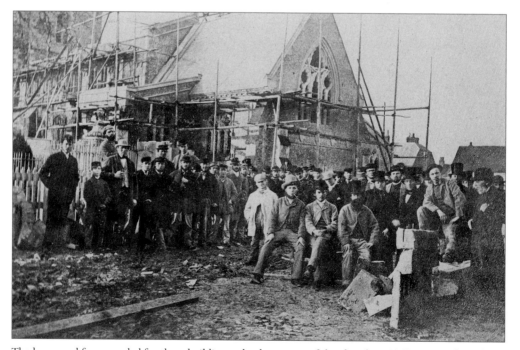

The large workforce needed for the rebuilding and enlargement of the church in 1869. A new chancel was built and the walls resurfaced with flint. The restoration was not completed until 1884 owing to lack of funds.

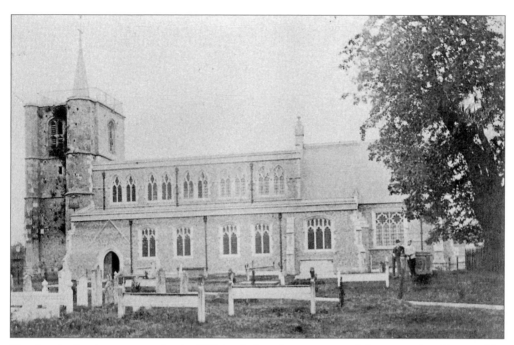

The church after its reconstruction in 1869 but before the restoration of the tower, the addition of the pinnacles and the rehanging of the bells in 1884.

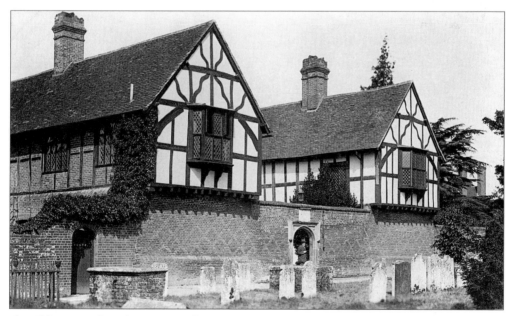

The Old Rectory dates from 1534 and incorporates a section of the old nunnery that it replaced. The building remained in use as the Rectory until 1868, after which time it became neglected and fell into decay. Sir Edward Lawson, later Lord Burnham, paid for it to be renovated in 1901 'in loving memory of his dear wife'. The building has recently been made into offices and flats.

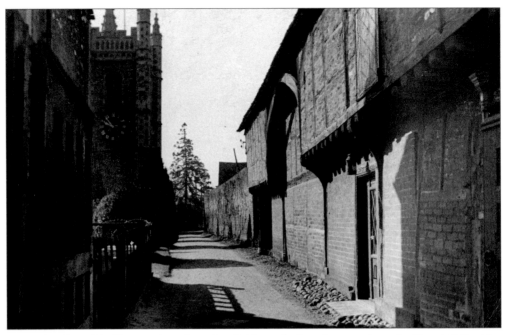

The timber-framed building on the right is Capel's House, built as the equivalent of a Church Hall with a £40 legacy left by Richard Capel, a former rector, who died in 1500. In recent years it has been made into two separate dwellings but has retained its timber framework.

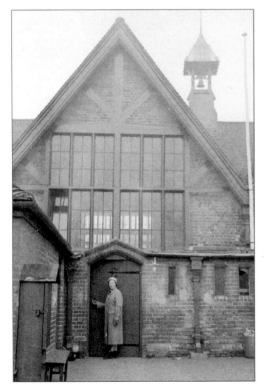

The Church of England School was built near the Old Rectory in 1872. This picture shows Peggy Steen, who taught here from 1956 until 1958 when she became deputy head teacher at the new Maxwell Road Church of England Primary School, which opened in that year. The old school building is now the Beaconsfield Masonic Centre.

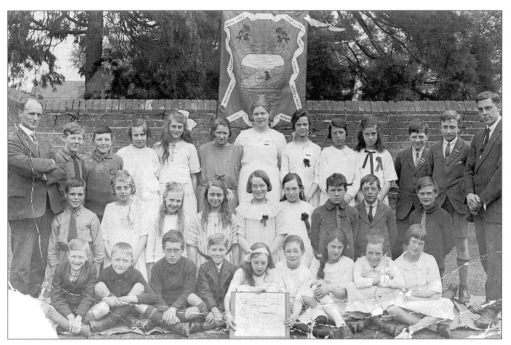

Pupils from the old school photographed in the 1920s. On the left is Mr Dyer, the head teacher.

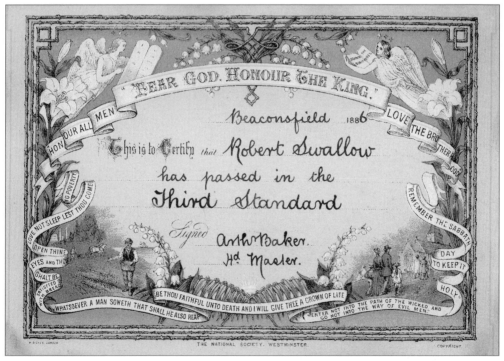

This certificate, with its strong stern Biblical wording, was framed and glazed, and no doubt proudly displayed by Robert Swallow's parents in 1886.

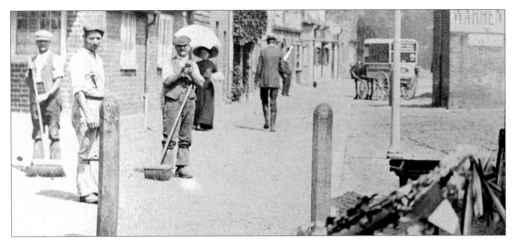

Aylesbury End in 1911. From left to right are Mr Reeves, Mr Hyde and Mr Gilder, obviously taking pride in keeping the pavement swept.

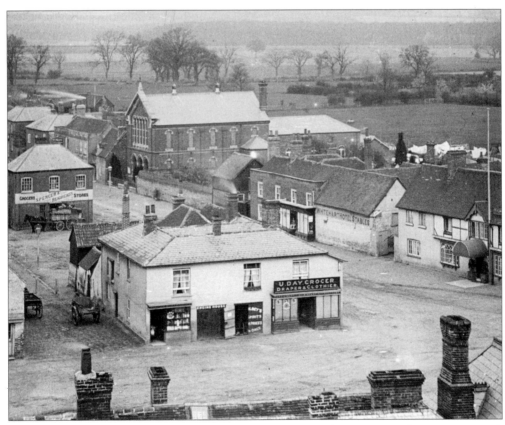

Augustus Day photographed this view from the church tower in about 1890. In the centre are Day's grocery, drapery and clothier's stores, since demolished, and several other familiar buildings which have survived. The most striking aspect of the scene is the rural background – farmland and trees as far as the eye can see.

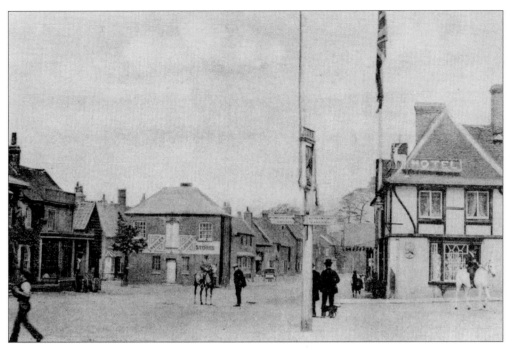

This photograph shows the side of the Day's Stores block on the left, the former lock-up in the centre and the White Hart Hotel on the right. This inn has always had its sign well away from the main building. In modern times the sign is on the other side of the road in Aylesbury End. The road signpost has been fixed to the shaft of the inn sign.

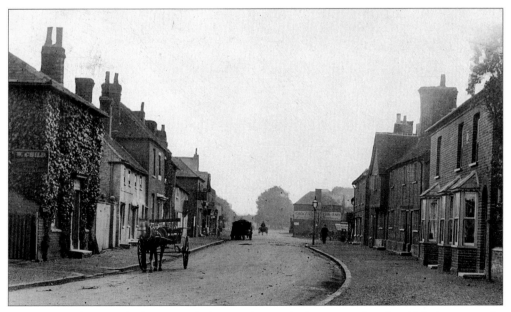

A view from the north looking up Aylesbury End towards the crossroads. The old lock-up is in the distance on the right and beyond may be seen the large trees in Windsor End. A solitary gas lamp sufficed for each of the four Ends.

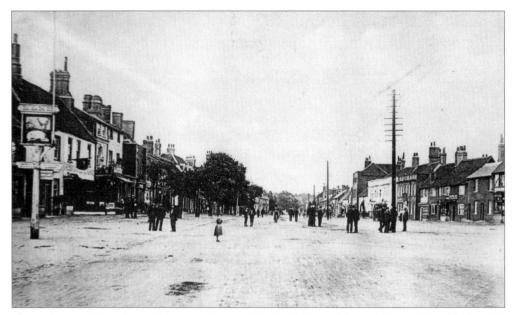

This wide view of London End captures the era after the decline of the coaching trade and before the arrival of the motor car. The date could be about 1900. In those days one strolled in leisurely fashion in the road, stopped to chat and turned to stare at a photographer. The inn sign on the left is that of the White Hart.

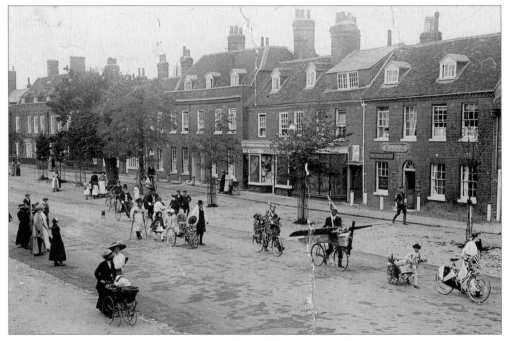

This procession along London End is thought to be on Hospital Sunday in 1918. One figure hobbles along on crutches, while another is in an invalid carriage; various decorated bicycles are being wheeled by their riders.

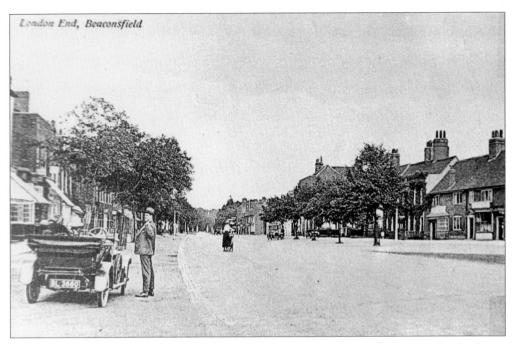

Another view of London End, but at a later date, probably the early 1920s. The man standing by the car may be Dr Pocock.

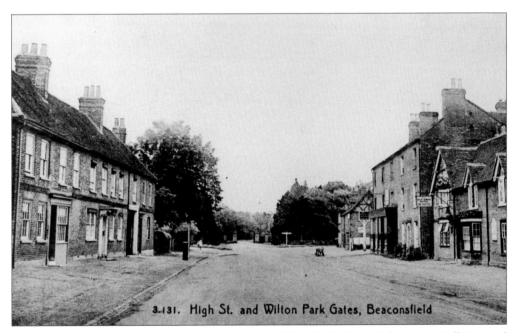

Further along London End, looking towards the gates to Wilton Park. On the left was once Bull Farm and the Bull Inn. On the right is the inn sign of the Old Swan and beyond that another inn sign of the White Horse. There are few items of what is now called 'street furniture' – a pillar-box on the left pavement, a horse-trough on the right, and at centre a wooden signpost.

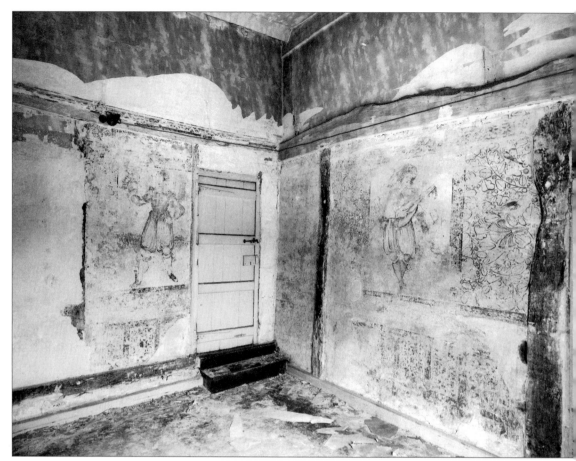

The house at no. 1 London End, near the corner with Shepherd's Lane, was probably lived in by the Waller family, including Ann, the mother of Edmund who built Hall Barn. In 1966 these wall paintings were discovered in an upstairs room of the house, hidden behind layers of wallpaper. There were three panels with figures as well as foliage with birds, fruit and flowers, also painted imitation panelling. The decorated areas of plaster wall were carefully removed from the house and transported to the Buckinghamshire County Museum.

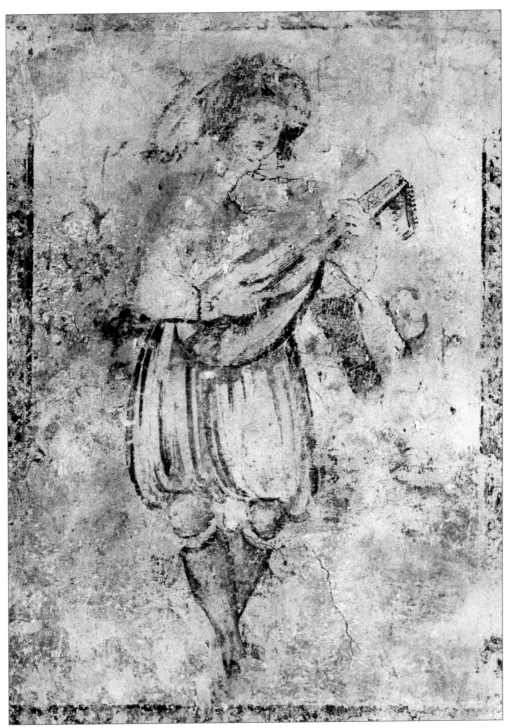

This delicately drawn panel, part of the plaster wall shown opposite, shows a young man playing a lute. He wears a floppy hat adorned with a feather, full breeches and hose tied below the knee with beribboned garters. His feet are crossed in an elegant pose. The main colours are brown and green with touches of red and pink.

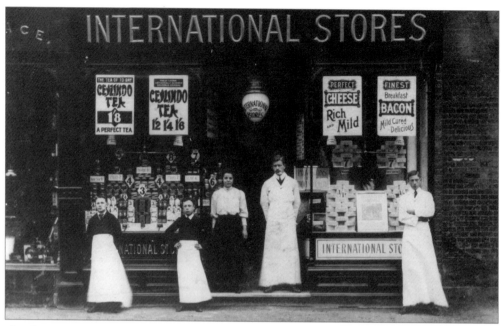

The photographs on these pages give some idea of the range of shops there used to be in the four Ends. The International Stores photograph is dated 1909 and posing outside are, left to right, 'Pudden' Child, Fred Giles, Lily Quartermain, -?-, and Walter Godly. The window-dressing style and the gas lamp in the doorway are typical of the period.

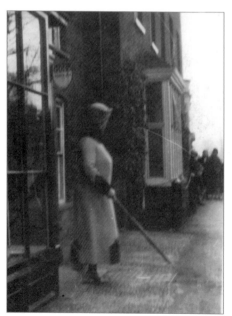

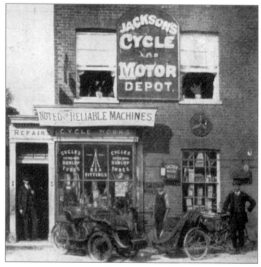

Jackson's Cycle and Motor Depot later became Ellis's cycle shop, and was next door to the chemist's in London End. The date is the early 1900s.

The unmistakable and dignified figure of Queen Mary, paying one of her regular visits to Brown's Antiques in London End, probably in the early 1930s.

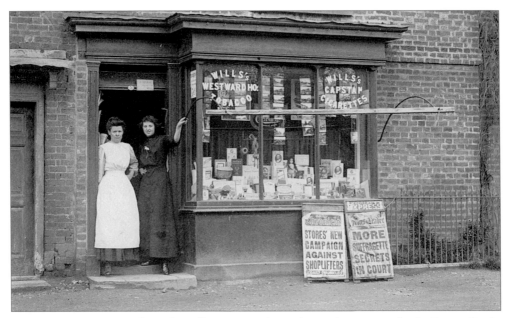

This shop at no. 71 Wycombe End is still a newsagent's. Until recently it was run by the Benyon family. The advertising boards on the pavement suggest that headlines haven't really changed much since 1912.

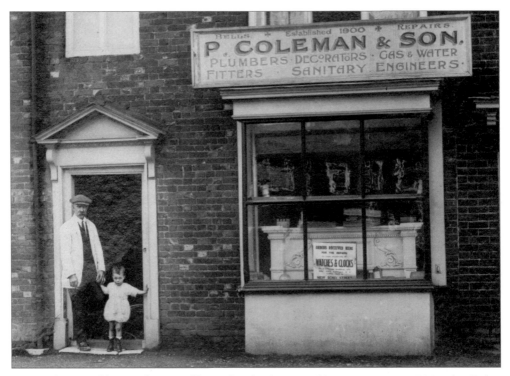

Percy Coleman and his grandson Harold Wood in the doorway of his premises at no. 14 London End in the early 1920s. This was later Puffins Teashop and since then has operated as several different restaurants. According to the noticeboard Mr Coleman offered a wide range of services.

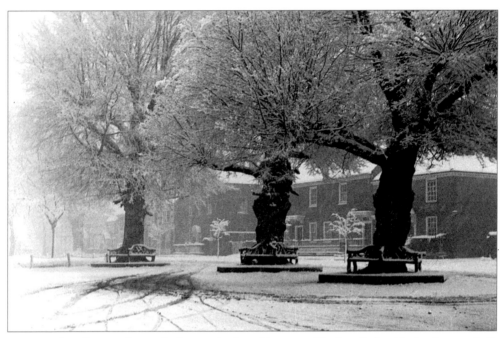

Many people will remember with pleasure the fine old trees in Windsor End, with circular seats built round the huge trunks. Sadly, they developed Dutch elm disease and had to be felled. The Council has planted new trees with sturdy protective frames to guard them while they grow to maturity. In the lower picture one can see that there used to be a tree outside the Saracen's Head. On the right is the old police station, built in 1870, one of the few Victorian buildings in the Old Town.

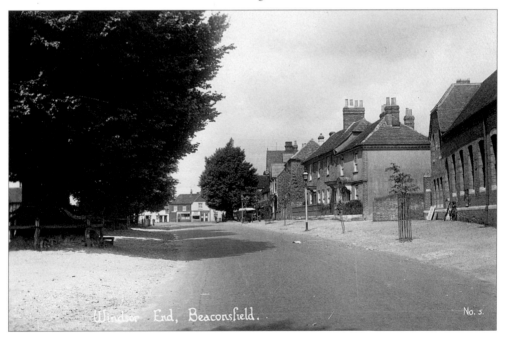

Windsor End, Beaconsfield. No. 5.

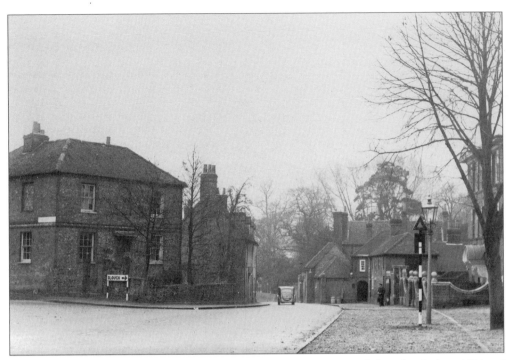

This is Windsor End at the junction with Hedgerley Lane. The house is Edith Lodge, built in 1900 and named after the sister of Lord Burnham. It was the residence of the headmaster of the old school and was demolished in 1956.

This photograph shows how narrow the road to Slough became on leaving the main area of Windsor End. This road was widened in 1956 to take the increasing traffic, and was later diverted to accommodate the motorway.

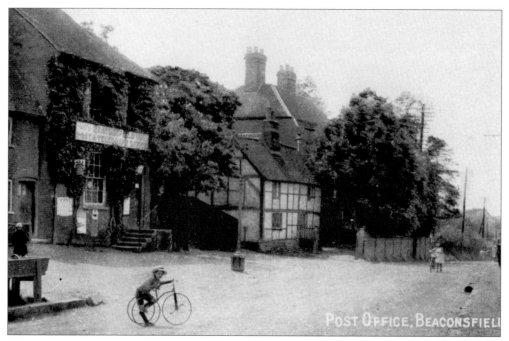

The post office, shown here in 1918, has long gone from Wycombe End but the building, now a private residence, retains the steps up to what was the entrance. The timbered building beyond it was pulled down in the early 1920s. The tall house behind is Wycombe End House. The large-wheeled tricycle is ridden by Arthur Thompson.

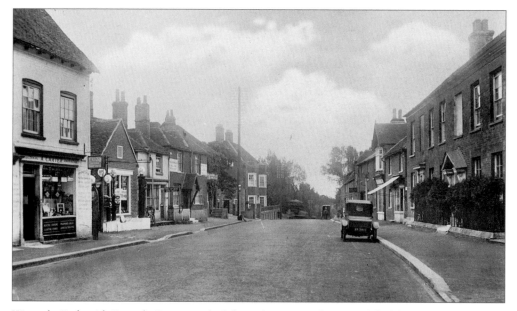

Wycombe End, with Brown's Garage on the left, in the 1930s. The Brown's buildings, a familiar part of the Old Town for many years, have recently been demolished.

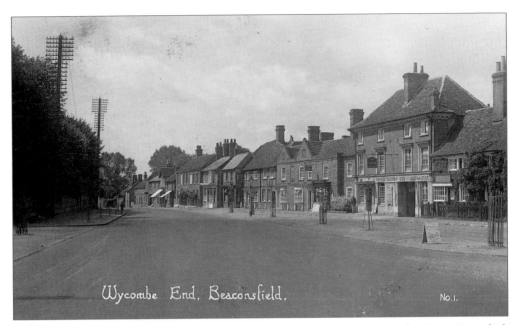

This is the wide area of Wycombe End once known as The Square. On the right is the George Inn, which dates from the seventeenth century. The trees on the left border the front garden of the large Queen Anne house known as Hall Place. For part of the nineteenth and twentieth centuries this was the Rectory.

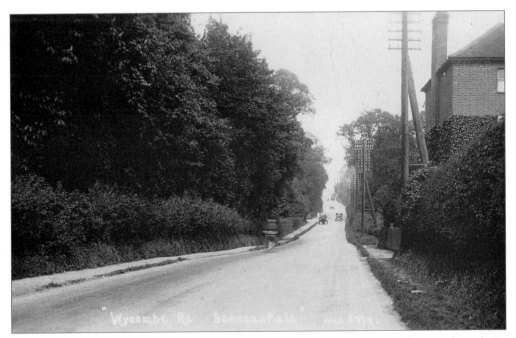

This photograph may not be immediately recognizable as the A40 looking up towards Wycombe End. On the right is York House, formerly the Star Inn, and the entrance to Wiggenton Farm. On the left, almost opposite, is an opening that once led to Wattleton Farm, later to Butler's Court. The trees have certainly grown since the man in the stove-pipe hat stood beside the telegraph pole (*see* p. 25).

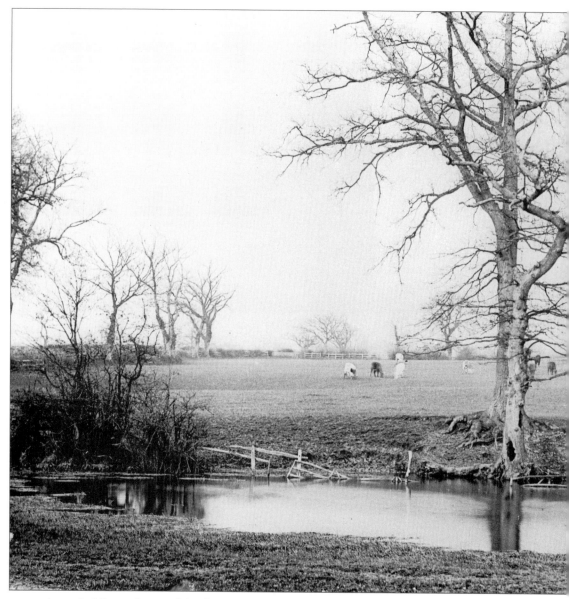

A wonderfully rural view of Candlemas Pond in the last century when all around were fields and open country. The tree on the right is still there, dead but decorative, with the hole in the trunk still visible.

THE INNS AND PUBLIC HOUSES

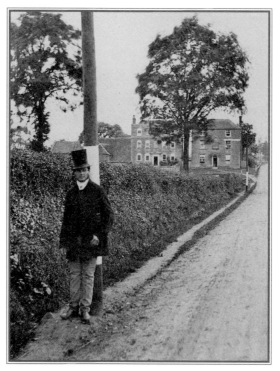

This picture dates from the 1860s when telegraph poles were erected along the road that later became the A40. The houses in the distance on the left were formerly part of Wiggenton Farm. They are still there, although obscured by trees from this viewpoint. The right-hand building was the Star Inn (now York House), numbered (1) on the plan overleaf.

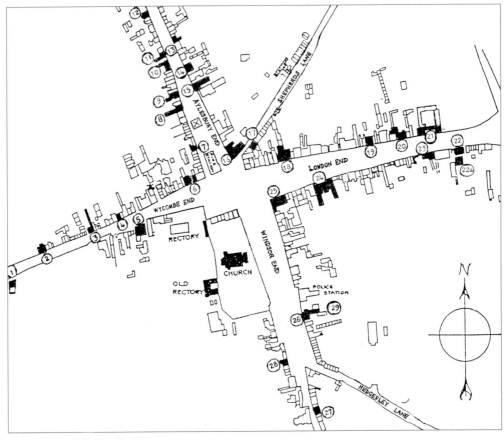

Key to Inns and Public Houses:
The numbers correspond to the numbers on the map, and the names are followed by the date of the earliest documentary reference.

1. Star
2. Black Horse
3. Prince of Wales (1871)
4. Orange Tree
5. Cross Keys
6. George (1428)
7. Old Elm Tree
8. Old Star
9. Old Hare (1707)
10. Queens Head
11. Warrior (1596)
12. Gunners Inn (1614)
13. Queens Head
14. Farriers Arms
15. Buckingham Arms

16. White Hart (1622)
17. Pascal Lamb (1669)
18. Kings Head (1507)
19. Quart Pot (1689)
20. Chequers (1652)
21. Bull Inn (1616)
22. White Horse (1707)
22a. White Horse (1900)
23. Old Swan (1675)
24. Crown (1487)
25. Saracen's Head (1545)
26. Greyhound (1645)
27. Plough
28. Red Ox (1707)
29. Old Brewery (1853)

The Old Town has boasted no fewer than twenty-nine inns over the centuries! Sometimes names were transferred from one building to another. There are still nine inns within the map area. The numbers in the captions throughout this section refer to this map.

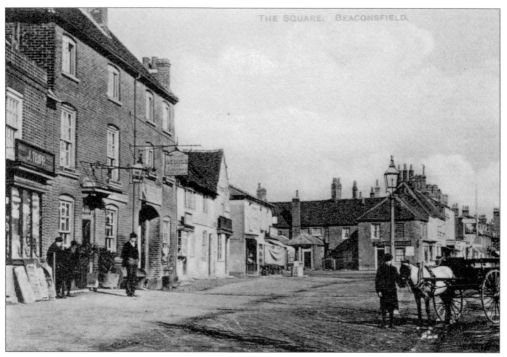

The George (6) on the left stands in the wide part of Wycombe End, formerly known as The Square.

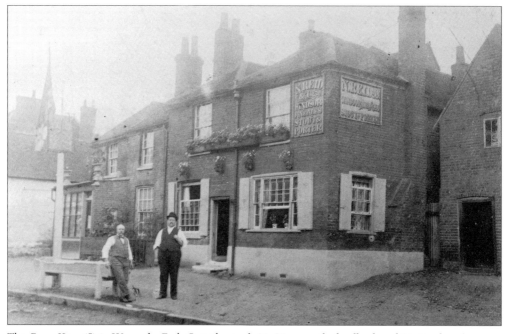

The Cross Keys (5) in Wycombe End. Outside stands Mr Morgan, the landlord, and Mr Stunham.

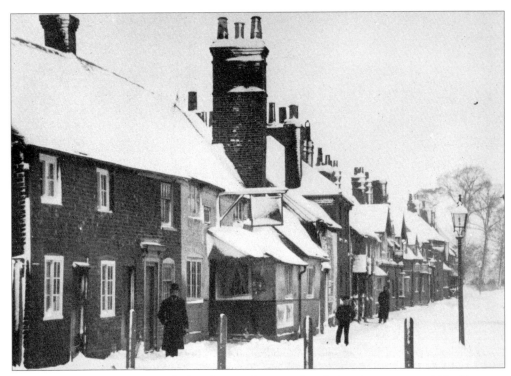

Aylesbury End – a snowy scene which unfortunately means that the inn signs are unreadable. However, there were three inns here: the Old Elm Tree (7), which no longer exists; the Old Star (8), now the Charles Dickens; and the Old Hare (9).

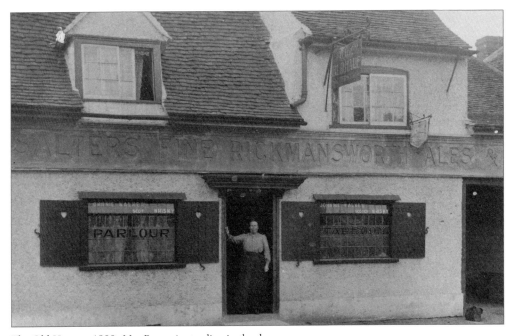

The Old Hare, *c.* 1900. Mrs Bunce is standing in the doorway.

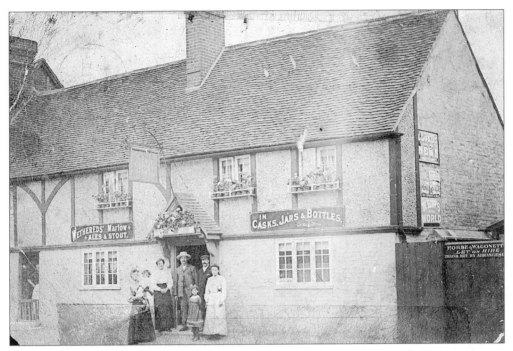

The Queen's Head (10) on the west side of Aylesbury End. The family is unknown. The notice on the gate to the right reads 'Horse and Wagonette Let on Hire/Trains met by Arrangement'.

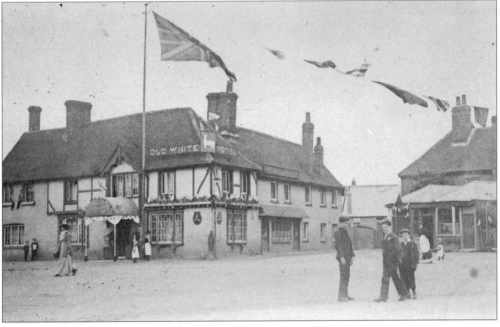

The White Hart (16), photographed when the flags were out to celebrate victories in the Boer War. The lettering on the roof is still there today, although the words have changed, and there is now also a model of a white deer.

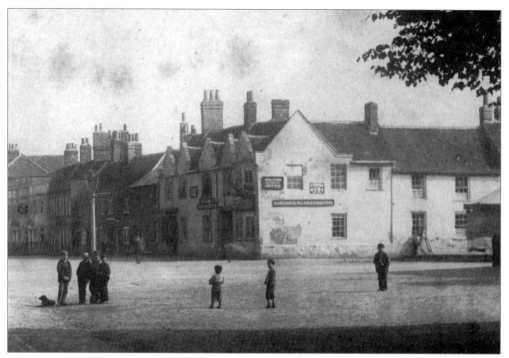

Two views of the Saracen's Head (25): the top photograph was taken in about 1885 and the lower one after 1890 when the building was renovated and fake timbering added to the outside. There is written evidence of an inn on this site in 1242. By 1545 it was known as the Saracen's Head, the name possibly derived from Crusaders returning from the Holy Land. In neither of these photographs does there appear to be a pavement or any other form of transition between road and pedestrian way.

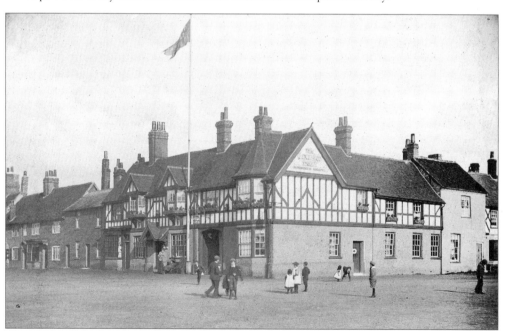

This house, known as Burke House on the left and Burke Lodge on the right, was once the Crown (24). The large double door in the centre led into a courtyard with stables where stage-coach horses were changed and fed. Claude Duval, a highwayman who operated locally, is said to have used the Crown. He was hanged at Tyburn for his crimes in 1670.

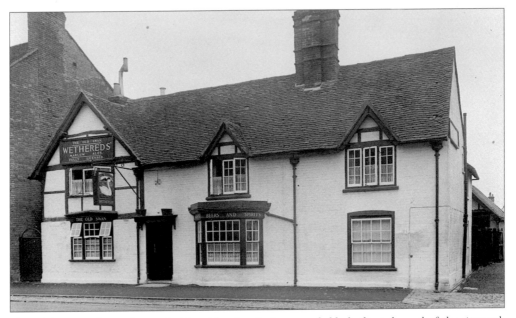

The Old Swan (23) on the south side of London End was probably built at the end of the sixteenth century. It has changed its name over the years and now bears a handsome sign reading 'The Old White Swan'.

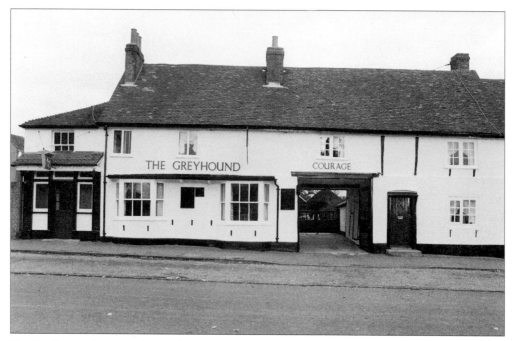

The Greyhound (26) in Windsor End probably dates from the seventeenth century. It appears on old maps as Ye Dogge. There is a courtyard beyond the large gateway.

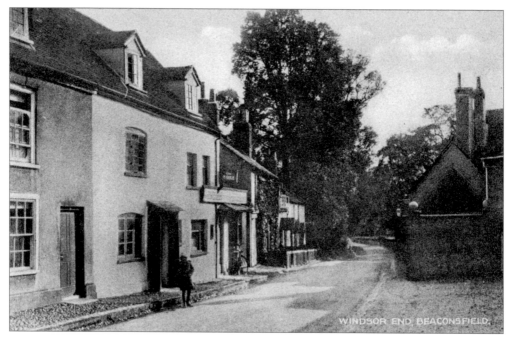

The Plough (27) in Windsor End. The Plough and the buildings beyond on the left were demolished between 1947 and 1956 to widen the road. Some of these were tied cottages for workers on the Hall Barn estate. On the right is Little Hall Barn, which was the dower house.

THE GREAT HOUSES

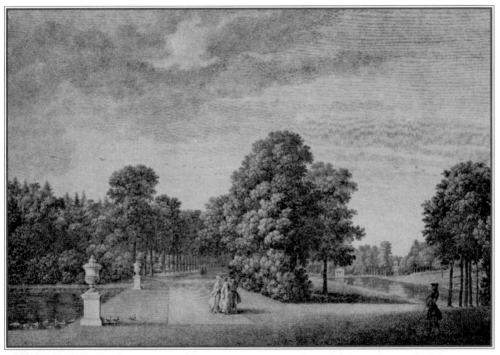

This print shows the gardens of Hall Barn, c. 1740. The long canal-shaped lake is on the right, with the Temple of Venus at the end reflected in the water. The gardens were laid out in the style of Le Nôtre, the design said to have been inspired by the grounds of the Palace of Versailles, but it is not certain how much was carried out by Edmund Waller, who built the house, and how much by his successors.

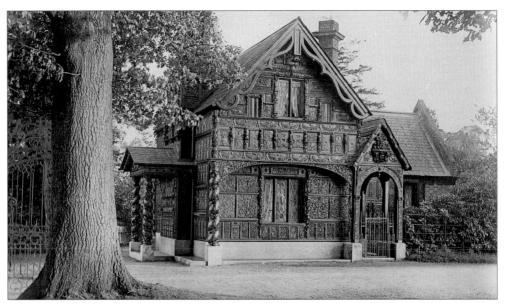

The Oak Lodge at the entrance to Hall Barn estate has its exterior covered with intricate wood carvings. Those on the upper storey were brought from Italy by Sir Gore Ouseley. The lower carvings were added after 1887 and were from a Belgian convent. Recently, when part of the woodwork was restored, a portrait head of the late Lord Burnham was included by local craftsman, Colin Mantripp.

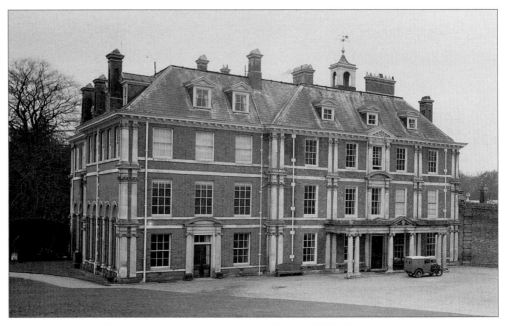

The front façade of Hall Barn as it looked between 1883 and 1972. The house was built by Edmund Waller, poet and parliamentarian, probably between 1675 and 1680. A library was added in about 1840 by Sir Gore Ouseley, the then owner, and a ballroom was added in 1883 by Sir Edward Lawson, later the first Lord Burnham. These additions, with other rooms, formed the wing on the left, which was demolished in 1972 to restore the house to its original shape.

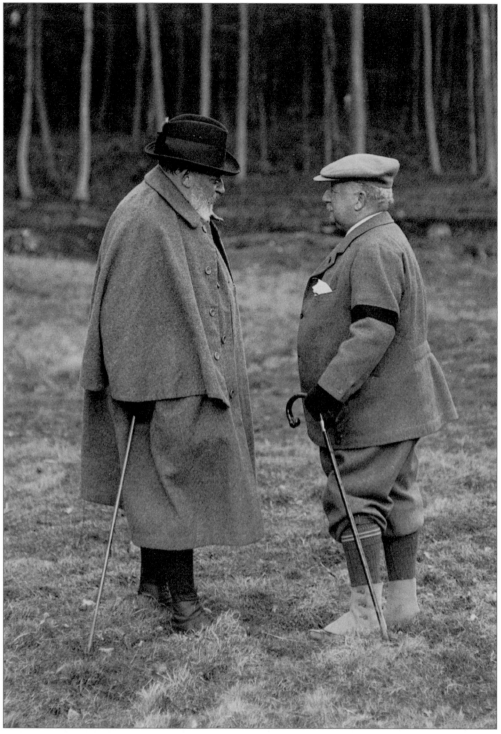

King Edward VII, and later his son George V, were both regular visitors to Hall Barn for the shooting. This photograph, taken on 24 January 1910, shows King Edward on the left talking to Lord Burnham, who founded the *Daily Telegraph*, and was created a peer in 1903.

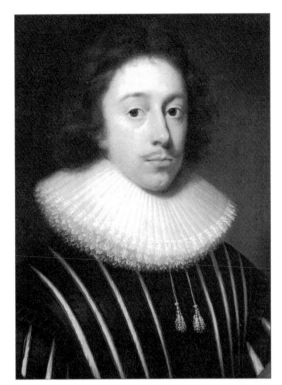

Edmund Waller ordered these portraits of himself and his lady-love 'Sacharissa' to be painted at the same time. The date is around 1635 when Edmund was about thirty and Sacharissa in her late teens. She was Lady Dorothy Sidney, the daughter of the Earl of Leicester. Tradition has it that Waller addressed to her his most famous lines:

> 'Go, lovely Rose,
> Tell her that wastes her time and me,
> That now she knows,
> When I resemble her to thee,
> How sweet and fair she seems to be.'

Despite this ardent wooing Lady Dorothy married another.

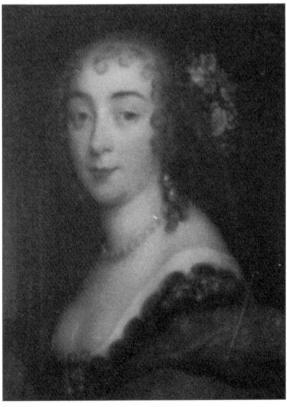

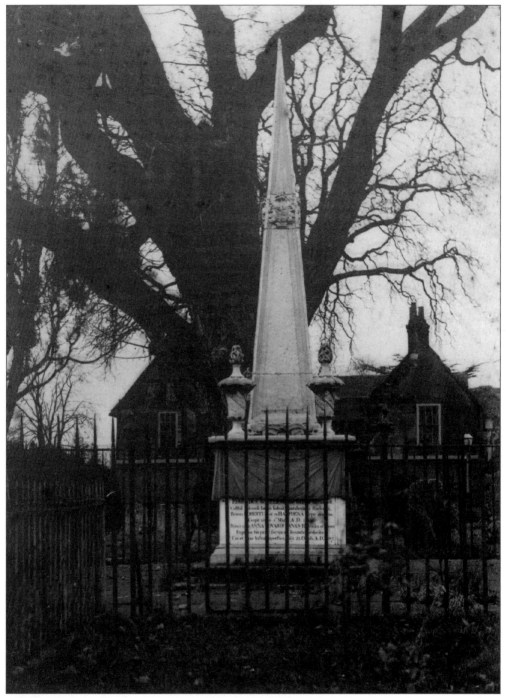

Edmund Waller died in 1687 after a remarkable career spanning the Civil War and the Restoration. His impressive tomb stands in the churchyard in the Old Town. Behind is the famous walnut tree planted at his death. The tree lived for nearly three centuries before succumbing to a storm. In the background is the Old Rectory before it was restored in 1901.

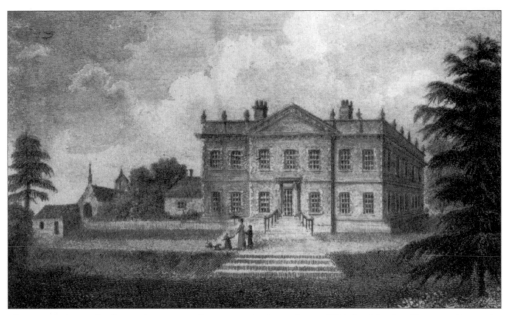

This print shows the house known as Gregories, built in about 1700 by Martha Gregory. From the footpath from Grove Road towards Walk Wood may be seen Martha's Terrace, a raised area that was at the back of the house.

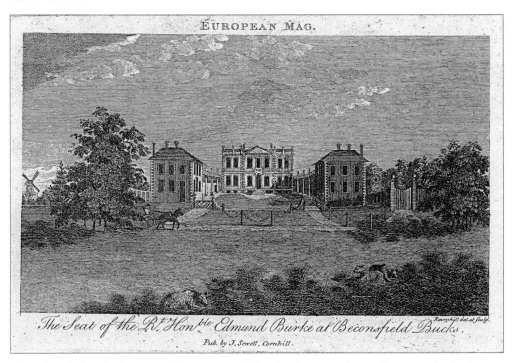

Edmund Burke bought the estate of Gregories in 1768, when he wrote, 'It is a place exceedingly pleasant; and I propose, God willing, to become a farmer in good earnest.' He extended the house in Palladian style with two wings and curved colonnades. Burke renamed the house Butler's Court after a dispute with Hall Barn over manorial rights. It was destroyed by fire in 1813, sixteen years after his death. Notice the windmill on the left – it was the first in Beaconsfield.

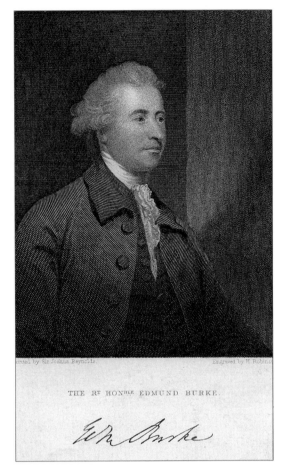

Painted by Sir Joshua Reynolds. Engraved by H. Robinson

THE RT HONBLE EDMUND BURKE.

Edmund Burke was the greatest parliamentarian of his day, writing and speaking eloquently on the American War of Independence and the French Revolution; even his enemies admitted he was the greatest of orators. During his occupancy of Gregories he entertained many famous men including Sir Joshua Reynolds, Dr Johnson, Charles James Fox, David Garrick and Oliver Goldsmith: his hospitality was renowned. Burke died in 1797 and was buried at his own request in the parish church.

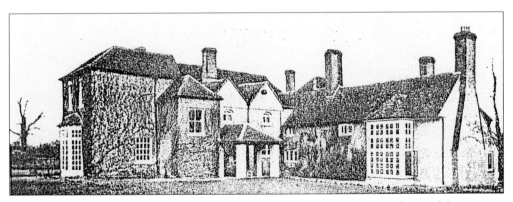

Gregories Farmhouse, built in the early sixteenth century, was the original manor house of the estate. In Burke's day it was occupied by his farm bailiff, William Rolfe. Sir Joshua Reynolds, a regular visitor to the great house, and in need of a model for his picture 'The Infant Hercules' (a commission from the Empress of Russia) painted Rolfe's large baby son. From 1921 the house was owned by J.L. Garvin, a famous editor of the *Observer*, until his death in 1947. It is now divided into two properties.

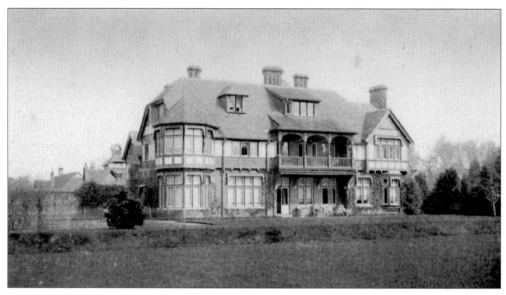

The new Butler's Court was built in 1891, long after the great house was destroyed by fire. Sited some distance from the earlier building, the present house was built and occupied by General Lord Grenfell who lived here until his death in 1925. After the Second World War the house was taken over by Wiggins Teape (now Arjo Wiggins Appleton) who use the premises and some adjoining land as a paper research establishment.

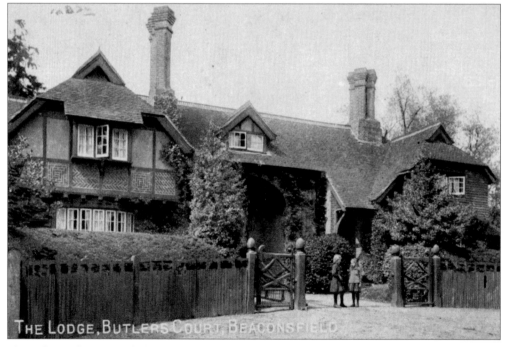

The Lodge to the new Butler's Court, built at the same time as the house. The lodge was demolished in the 1960s, but the name is remembered in Old Lodge Drive on the Wattleton Estate. The pond, which still exists on the north side of the A40, was beside the lodge.

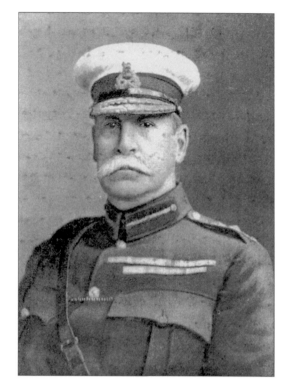

Lord Grenfell was related on his mother's side to the Du Pres of Wilton Park. He was born in 1841 and spent most of his distinguished military career in Africa at a time when the continent was being explored and opened up for development. He commanded in Egypt, and in 1898 became Governor-General of Malta. Raised to the peerage in 1902, Grenfell's final period of service was as C-in-C, Ireland from 1904 until 1908 when he was promoted to Field Marshal.

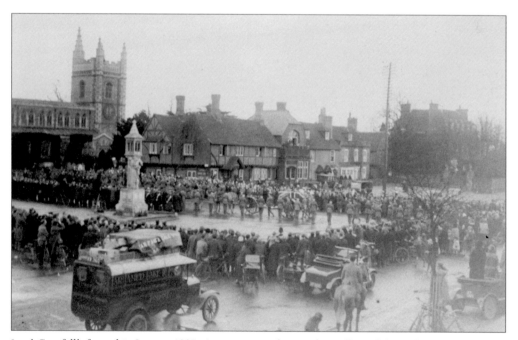

Lord Grenfell's funeral in January 1925. A gun-carriage bearing his coffin and drawn by a team of horses is on its way to the parish church, watched by a large crowd of local residents. The First World War Memorial stood near the centre of the four Ends before being moved to its present position in 1934.

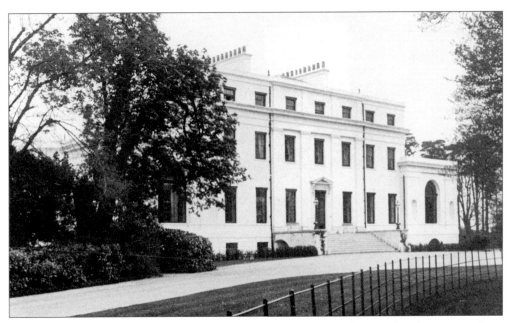

Two views of The White House, Wilton Park, built by Josias Du Pre, who retired to this estate in about 1770 with the fortune he made when he was Governor of Madras. The family was prominent in Beaconsfield during the nineteenth century. James Du Pre, Josias's son, was an MP in various constituencies from 1800 and High Sheriff of Buckinghamshire in 1825. His son, Caledon George (whose name is remembered in Caledon Road), was Conservative MP for the county from 1839 to 1871. The Misses Du Pre, James's daughters, started a school in the Old Town in the middle of the nineteenth century.

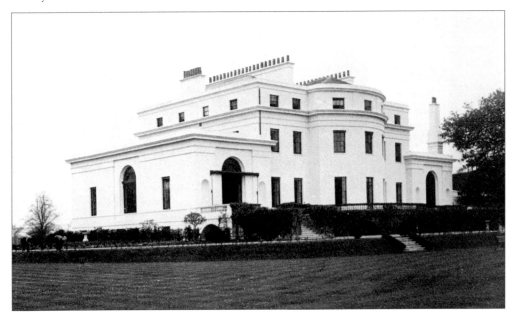

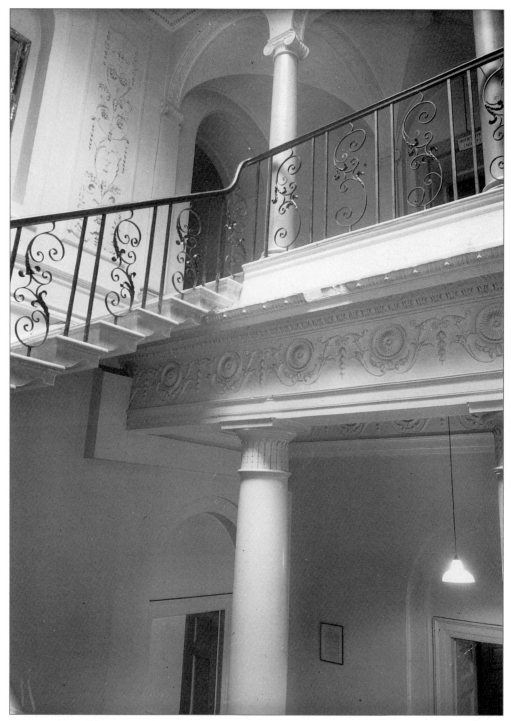

A view of the Adam interior of The White House, showing the fine plasterwork and the wrought-iron balustrade by the staircase.

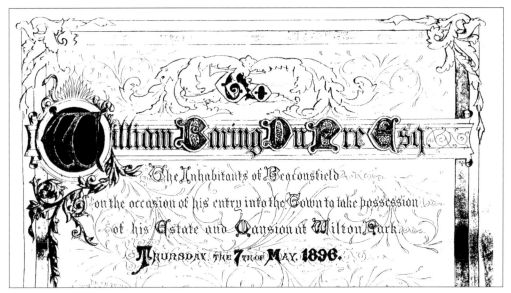

In 1896 William Baring Du Pre, heir to the estate of Wilton Park, came of age and great celebrations were held in his honour. This is the heading, in elaborate and beautiful calligraphy, to the Loyal Address presented to him by 'The Inhabitants of Beaconsfield' on the day he arrived at Wilton Park on leave from his battalion in Malta. He was then a Second Lieutenant serving with the 2nd Battalion, King's Royal Rifle Corps, having been commissioned in 1895.

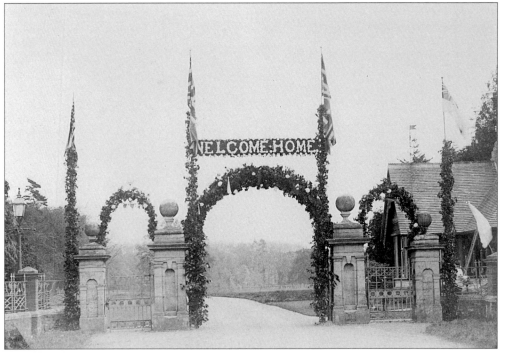

The gates to Wilton Park were decorated with evergreen garlands for William Baring Du Pre's homecoming to take up his inheritance.

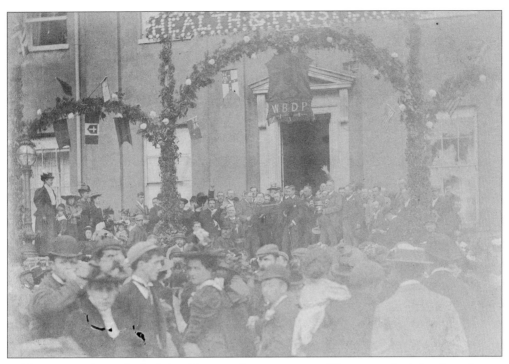

Celebrating crowds outside the White House on the same occasion. There are garlanded arches, a banner reading 'Health & Prosperity' and another with the initials W.B.D.P. over the front door.

William Baring Du Pre served in both the Boer War and the First World War. He was High Sheriff of Buckinghamshire in 1911 and MP for High Wycombe from 1914 to 1923. He died in 1946. The estate was taken over by the War Office at the beginning of the Second World War and was used as a centre for the interrogation of the most senior prisoners-of-war, including Rudolf Hess. The White House was demolished in 1967 to make way for the present assembly of buildings now used by the Army College of Military Education and Training Services.

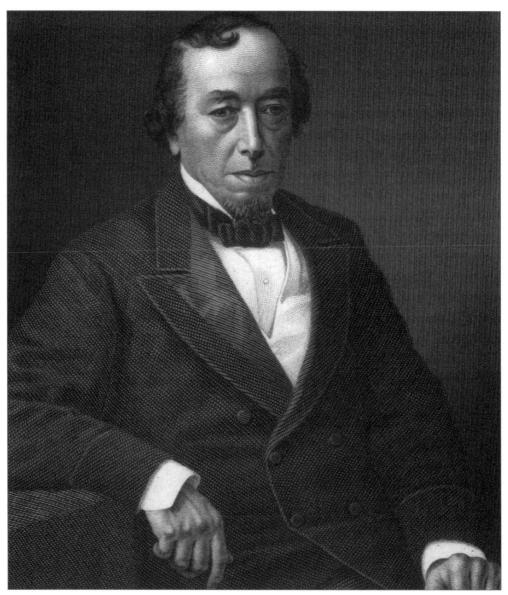

Benjamin Disraeli, 1804–1881, was the favourite statesman of Queen Victoria and Prime Minister from 1874 to 1880. In 1868 Mary Anne, Disraeli's wife, who was his senior by fifteen years, became a Peeress in her own right. It is thought that in choosing Viscountess Beaconsfield for her title she simply chose a place near to Hughenden Manor, Disraeli's estate. Mary Anne died in 1872 and it was not until 1876 that Benjamin was ennobled, taking the title Earl of Beaconsfield. In the early 1880s various towns in the British Empire adopted the name of Beaconsfield as a mark of respect for the Prime Minister of the mother country, rather than from any link with the Buckinghamshire town. Thus there are three Beaconsfields in Australia (near Melbourne, near Sydney and in Tasmania), one in Canada (near Montreal), and one in South Africa at Kimberley. Many streets in Britain and overseas are named Beaconsfield. Interestingly, Disraeli insisted on pronouncing his title 'Beakonsfield', as do the inhabitants of the Commonwealth towns. So many people associate Disraeli, Earl of Beaconsfield, with our town that we decided to include a few words here to clarify the situation. Disraeli himself had no links with Beaconsfield.

THE CONVALESCENT HOME

This Victorian house in London End (now Peter Knight, the house furnishers), was opened in 1910 with accommodation for six children. The Hospital for Sick Children in Great Ormond Street, London, supplied many of the patients. 'The idea is to take the children free and to give them good plain food, fresh air and care, for as long as is considered necessary for each particular case,' wrote Miss Gladys Meates, appealing for funds before the home opened. Miss Meates and her friend Miss Edith Hennell collected £50 to start the Home.

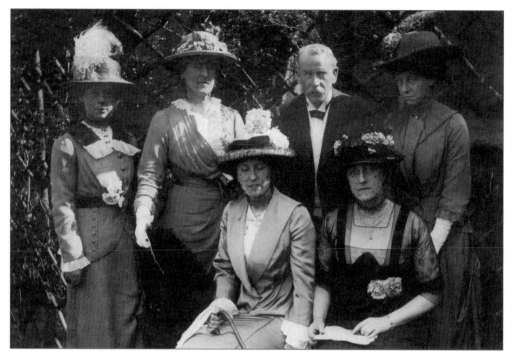

The Management Committee of the Home on 28 June 1910, the day of the official opening. Left to right: Ethel Skinner, Edith Hennell (the founder), Gladys Meates, Biscoe Tritton (Chairman), Katherine Meates, Rita de la Pena.

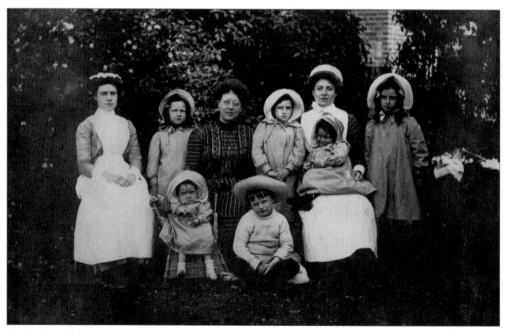

The first six children with (left) Nurse Lily Street, (centre) Miss Bertha Meates, Lady Superintendent and (right) Nurse Susie Platts.

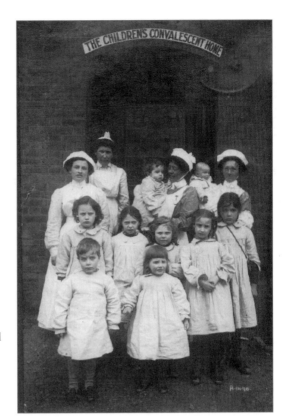

In 1913 the next door house was taken over and connected to the existing premises. Five more cots were added and two extra nurses engaged. This picture, taken at the front door of the original house, shows Miss Adelaide Williams, the Matron, at centre.

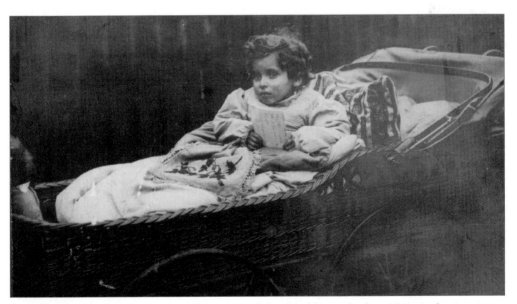

A young patient in a basket-work invalid carriage with hood and large wheels in 1913. At this time it cost 6s. 6d. a week to keep a child in the Home. Their stay was free, but the return train fare from London of 1s. 5d. had to be pre-paid by the parents. 'There are terrible scenes when the children have to go back,' said Miss Hennell to the *Daily Mirror*.

White Barn on Station Road in the New Town was the Home's second premises. The house, with two acres of garden, was bought in 1921 for £4,500, of which £1,000 was contributed by the Shaftesbury Society.

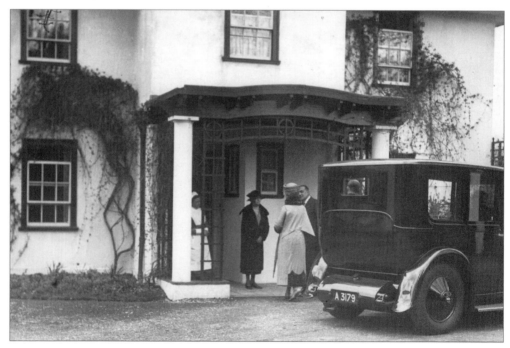

Queen Mary being greeted by the Matron, Miss Gooch, when she visited the Home on 23 April 1931. Two days later Miss Hennell received a letter from Windsor Castle, handwritten by the Queen's Lady-in-Waiting, Lady Desborough, saying how delighted the Queen had been with 'all she saw and the happy looks of the little children'.

Hurried out of Hospital —to where?

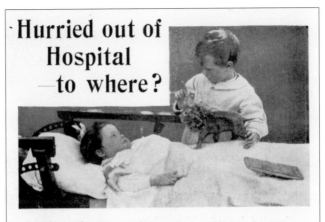

PICTURE the ward of a big London Hospital. A poor mother has come to receive back her little child, snatched from the jaws of Death, and now safely on the way to health.

The child, though still weak, must leave the hospital to make room for another. Must— for the demand for beds is insistent. Complete recovery must be found elsewhere. It is a question of life or death for some other sick child waiting for the bed.

The essentials to her child's recovery are not to be found in her over-crowded dwelling in the slums. It is a terrible thought for such a mother. Happily, for hundreds of them, the problem has been solved by the

Beaconsfield Convalescent Home, Bucks.

Will you give these little ones a chance to live?

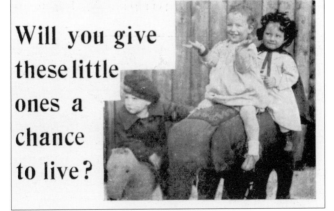

In 1925 a leaflet was distributed to subscribers, appealing for funds to extend the accommodation at White Barn: '£1,600 is required immediately to complete our new building'.

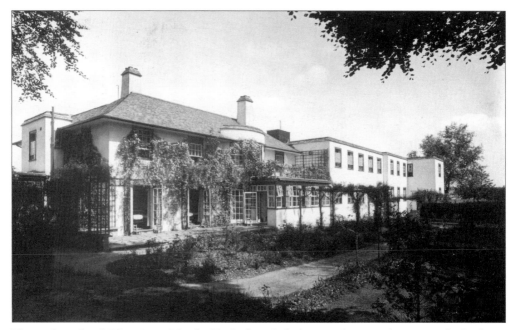

The garden side of White Barn. The far block, for which the appeal was made, consisted of a dining room, play room and isolation block. The new additions were opened on 5 May 1925 by Lady Burnham.

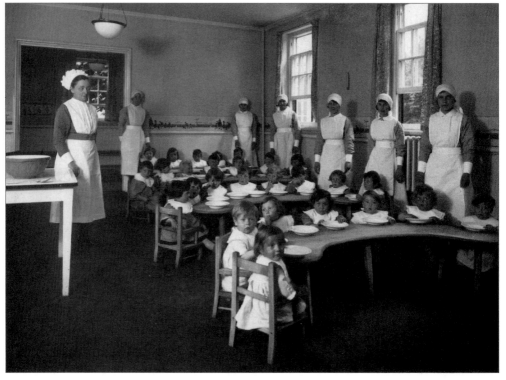

The new dining room. The Matron, Miss Edith Gooch, is on the left.

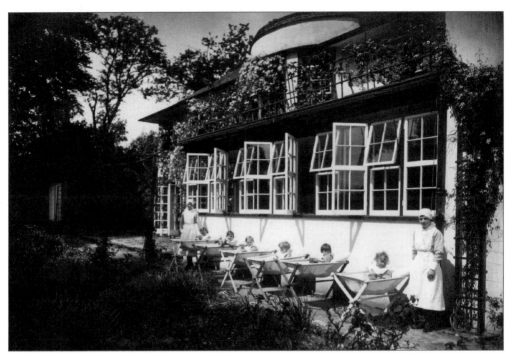

Settling down for an afternoon rest. The children are outside the building on the left of the picture opposite.

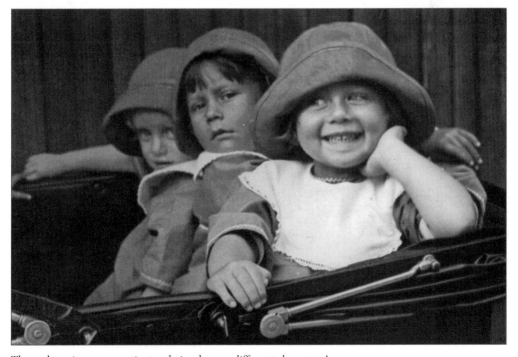

Three charming young patients, obviously very different characters!

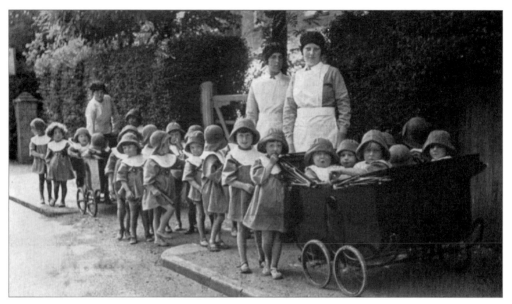

The neatly uniformed children with their nurses outside White Barn. This picture formed the heading of a 1935 Appeal in which Miss Hennell hoped 'that some of our subscribers may feel that an extra donation of 2s. 6d . would be a suitable way of commemorating this Jubilee Year'.

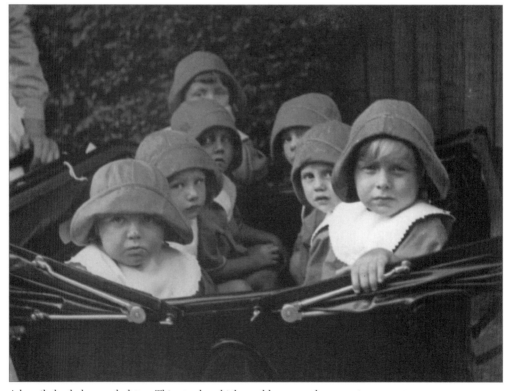

A heavily loaded perambulator. This sturdy vehicle could apparently carry six youngsters.

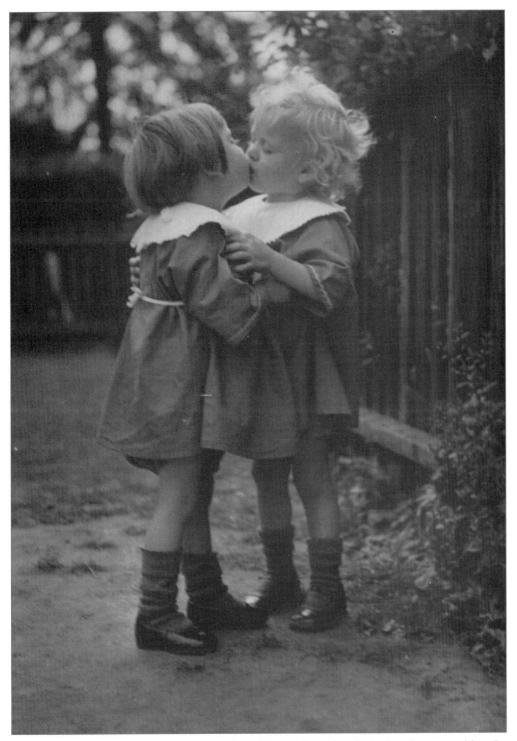

The young patients were fitted out with overalls with large bibs tied at the back with tapes, and hats for outdoor wear. Boys and girls were dressed alike.

The founder of the home, Miss Edith Hennell (left) and her friend Miss Gladys Meates. Miss Meates died in November 1940 and Miss Hennell wrote to subscribers saying that she would carry on the work. In 1942 Miss Hennell handed over the running of the Home to the Trustees of the Shaftesbury Society. She died in December 1946. The Home continued at White Barn until 1967 when the house and grounds were sold to Hughes Garage. Later the house was demolished. The album containing these pictures was in the possession of Miss Dorothy Collins, a member of the Management Committee and the Honorary Secretary of the Home. Miss Collins was also for many years secretary to the author G.K. Chesterton.

TRANSPORT AND THE COMING OF THE RAILWAY

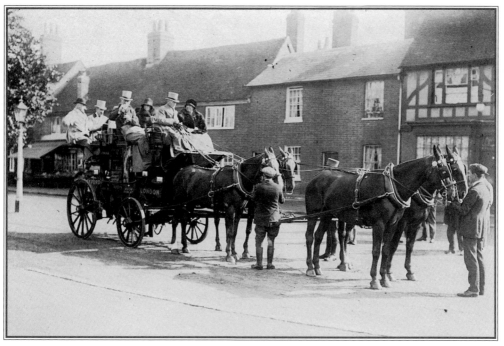

An original London to Oxford stage-coach in Windsor End, brought out for fun in the 1920s. The Old Town was a staging post where many inns provided stabling and refreshment.

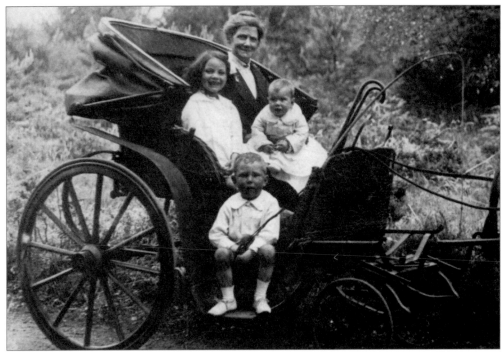

Members of the Perfect family on an outing to Burnham Beeches in 1922.

A taxi awaiting passengers outside the newly built railway station where the first trains ran in 1906.

Baskets of cherries, each holding 24 lb, ready for transport from Seeleys Farm to Beaconsfield station in about 1920. The baskets were loaded on to special railway carriages and taken to cities such as Leeds, Nottingham and Derby to be on sale the next day.

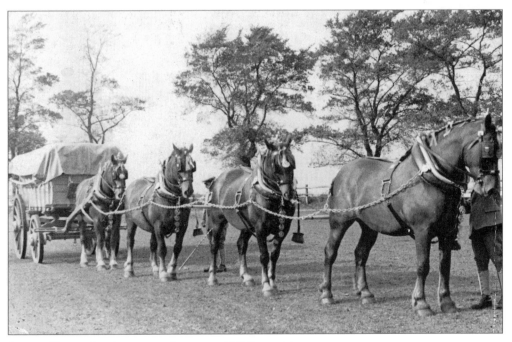

A team of horses drawing a covered wagon on Hall Barn estate.

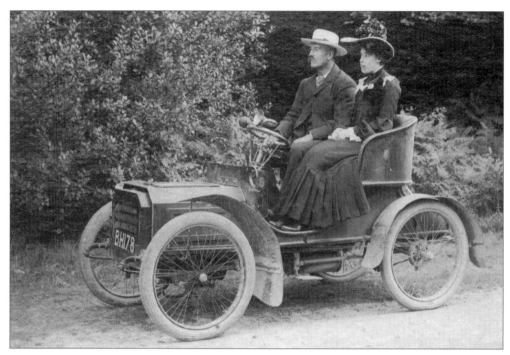

One of the first motor cars in Beaconsfield. Mr and Mrs Gower in their Humber Voiturette in about 1903.

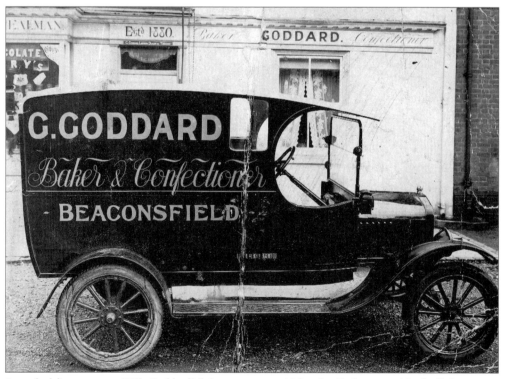

An early delivery van, *c.* 1910. Goddard's bakery was at no. 41 London End, next to Morford's Stores.

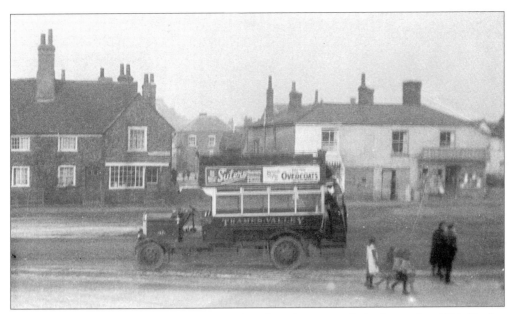

An uncrowded scene at the centre of the four Ends with Day's Stores in the background, *c.* 1924. The bus is a Thames Valley double-decker with an open staircase to the upper section. There was one bus daily, from Uxbridge to High Wycombe and back.

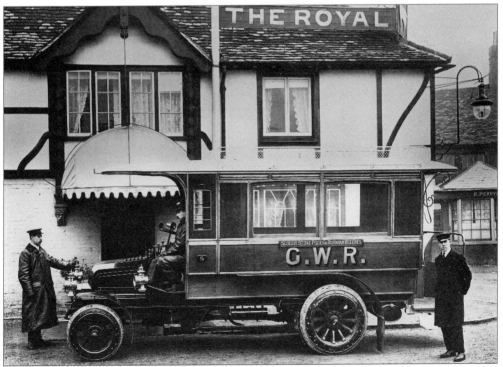

Before the arrival of the train service at Beaconsfield the Great Western Railway operated buses like this, with smartly uniformed chauffeurs, to convey passengers to the nearest railway stations. This picture was taken outside the White Hart, probably in 1908, shortly before the service to Slough terminated.

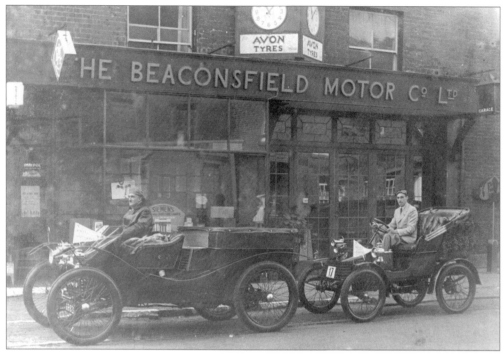

The Old Town service station in London End in the early 1930s. Two vintage cars are ready for a rally, a Lanchester on the left and a 1905 Wolseley on the right.

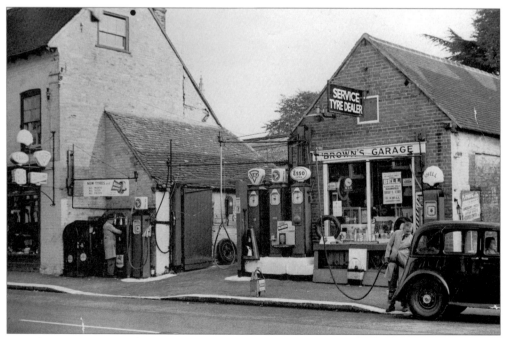

Brown's Garage in Wycombe End in the 1950s, when each pump served a different brand of petrol. William Brown is on the left and Ethel Brown is having her tank filled.

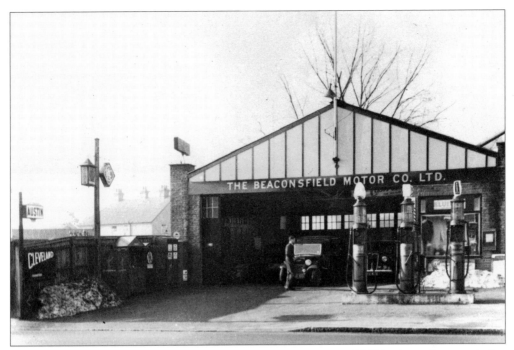

The Beaconsfield Motor Co. Ltd garage in the New Town is now Beaconsfield Honda, on the same site but with a radically altered building. In 1936 the petrol pumps were the 'lighthouse' style. At the top of the tall pole to the left are signs for the Automobile Association and the Royal Automobile Club.

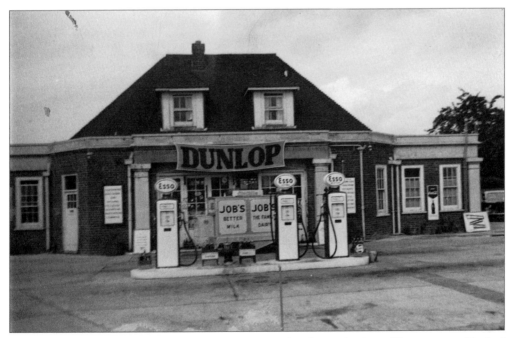

Holtspur service station was on the corner of the A40 and Holtspur Top Lane. There is now a block of flats – Beaconsfield Mews – on this corner, and an Esso service station on the next site along the A40.

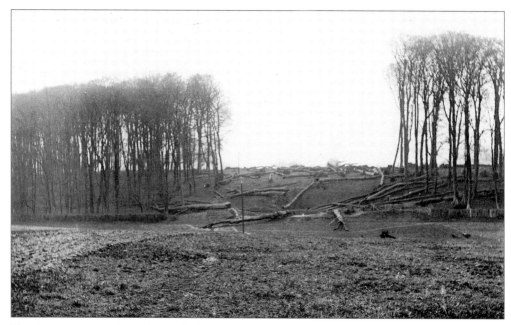

This dramatic picture shows the swathe which was cut through a strip of woodland in preparation for the building of the railway. Work on the new line began in 1901.

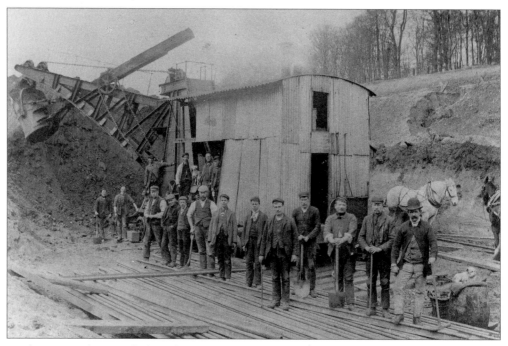

A railway cutting being made through Wilton Park estate, using a 'steam navvy' with a long-armed shovel. There were twelve of these on the section from Gerrards Cross to High Wycombe, also 29 small steam locomotives, 500 tipper wagons, 100 trucks and 50 horses. Some two thousand men, many of them itinerant Irish, were employed. They lived in huts in a depot at Gerrards Cross while the work lasted.

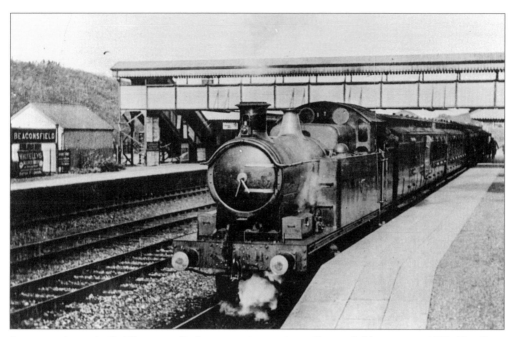

A steam train on the Paddington to Banbury stopping service at Beaconsfield station, *c.* 1910. The Great Western and Great Central joint line was the last mainline railway to be built in England.

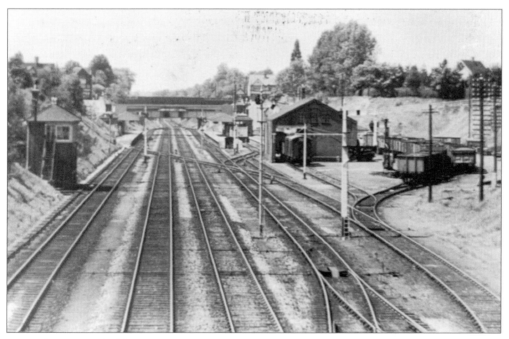

Beaconsfield station had four tracks until the 1970s. This arrangement allowed expresses to run through non-stop at speed, with local trains standing safely beside the platforms. There was also a goods yard and coal depot where the modern car park is.

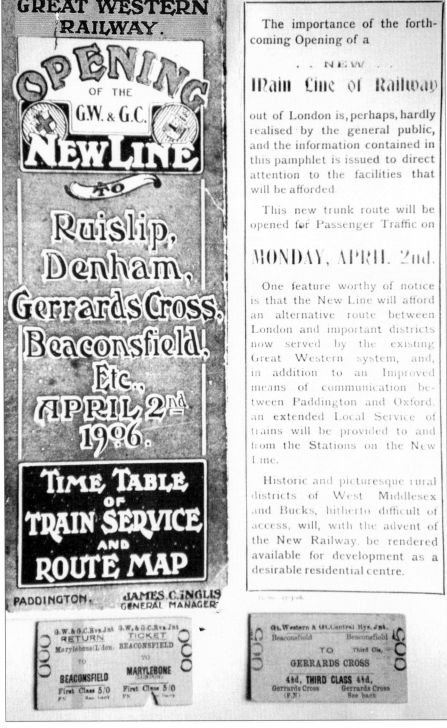

Beaconsfield's first railway timetable. The first ticket, number 000, was issued to Job Wooster by the new station-master who lodged at Seeleys Farm until his house was built. The single third class fare to Gerrards Cross was only 4½d.

THE NEW TOWN

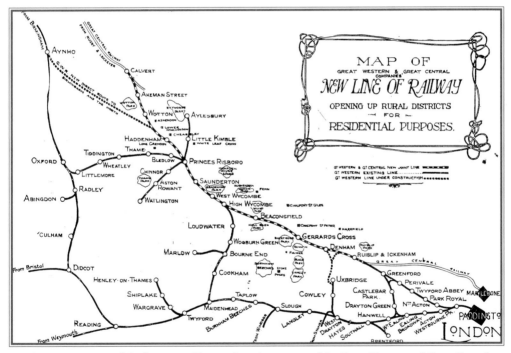

This map was part of the first timetable issued on the opening of the Great Western and Great Central companies' joint railway line between London and the Midlands passing through Beaconsfield. The first train ran on Monday 2 April 1906 and 'opened up rural districts for residential purposes' as the timetable proclaims. The first class fare to London from Beaconsfield was 3s. 4d. single and 5s. return, and the journey took forty minutes.

Beaconsfield.

On the new Main Line of the Great Western & Great Central Joint Committee, about 40 minutes from London, with splendid service of Trains to Marylebone and Paddington, with inter-communication to all parts of London, including several of the new Tubes, thus making it easy of access, not only to the West, but to the City and the Northern Railways.

Particulars, Plans, Stipulations & Conditions of Sale

of the

SECOND PORTION OF

BURKE'S ESTATE,

—————— INCLUDING ——————

About 100 FREEHOLD PLOTS

Being the second section of the Estate, which extends to some **300 Acres**, is magnificently timbered, and includes the site of the house of the great Statesman, **The Right Hon. EDMUND BURKE**, known as

"Gregories,"

ADJOINING IS BURKE'S GROVE,

The Favourite Walk of the Statesman,

and an

OLD-FASHIONED COUNTRY FARMHOUSE,

With Fine Garden and Orchard.

It is a wonderfully healthy and bracing district, some 400 feet above sea level, and the Estate extends right up to the old-world village of Beaconsfield. The neighbourhood generally comprises Gentlemen's large Country Seats, including Butler's Court, belonging to Lord Grenfell, Penn House, of Earl Howe, G.C.V.O., Wilton Park, the seat of W. B. Du Pre, Esq., J.P., and Hall Barn, of Lord Burnham, Sir John Aird, Bt. Until recently it was almost impossible to buy land for building purposes, and its present accessibility, owing to the new Lines, makes it probably one of the most desirable districts in the Home Counties.

Gravel Soil. Gas, Water and Electric Light to the Main Roads.

MESSRS.

CURTIS & HENSON

Are instructed by the owners to **SELL BY AUCTION** such portions, as may not be previously disposed of by Private Treaty, of the second section of this magnificent Building Estate,

IN LOTS, AS PER PLAN,

IN A MARQUEE ON THE ESTATE,

On WEDNESDAY, the 24th day of JULY, 1907,

AT 2 30 O'CLOCK PRECISELY.

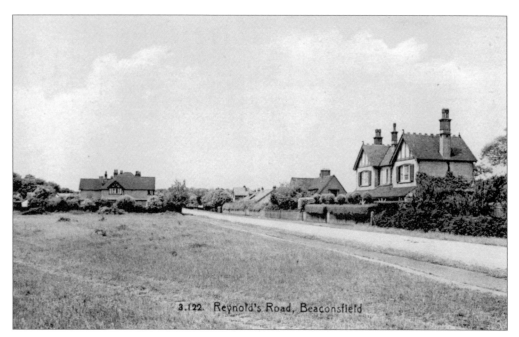

From the early years of the twentieth century farm land was sold from surrounding large estates. Roads were laid out from about 1903 and plots offered for sale, as in the estate agent's advertisement opposite, encouraging people to buy houses in Beaconsfield and commute to London. The New Town grew up in this way and these photographs show early views of the first developments. Reynolds Road has just a few houses with plenty of room for more.

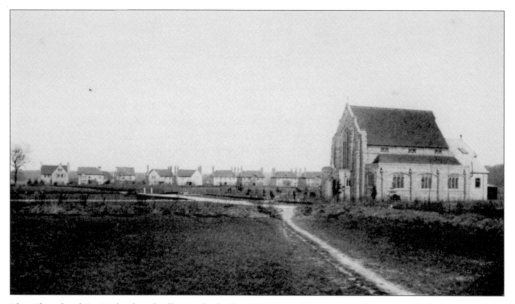

The Church of St Michael and All Angels, built in 1917, still has space all round it. The houses in the background are in Ledborough Lane, which was laid out with house plots as early as 1903.

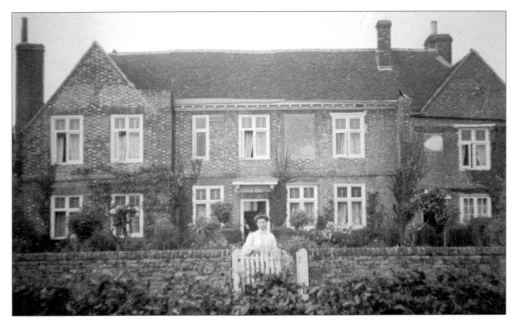

This is May, the daughter of Job Wooster who farmed at Seeleys. The farmhouse dates back to the sixteenth century. Although it is now completely surrounded by modern dwellings the front entrance still leads on to a country lane.

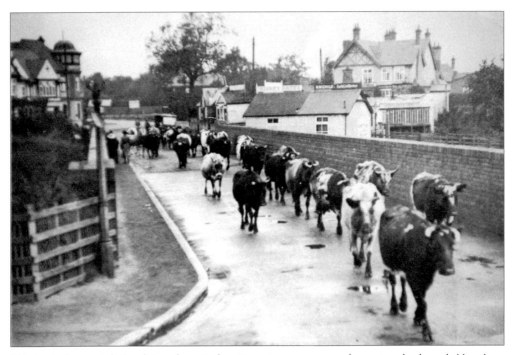

This herd of cows is being driven from Seeleys Farm to graze on nearby pasture land, probably where Maxwell Road is now. The date is about 1907. In the background the tall building on the right is the Railway Hotel, and in front are temporary huts which housed some of the New Town's first businesses.

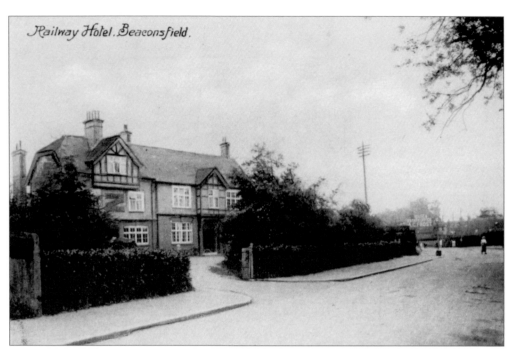

The Railway Hotel was built in 1907, and had extensive stabling for horses despite the 'Railway Age' having reached the town.

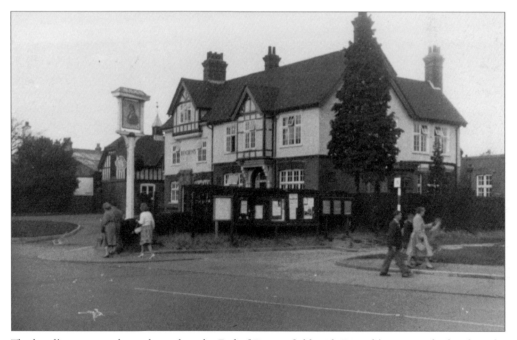

The hotel's name was later changed to the Earl of Beaconsfield with Disraeli's portrait displayed on the signboard. The hotel was demolished in 1981 and a Waitrose supermarket, designed by architect Sir Hugh Casson, was built on the site and opened later the same year.

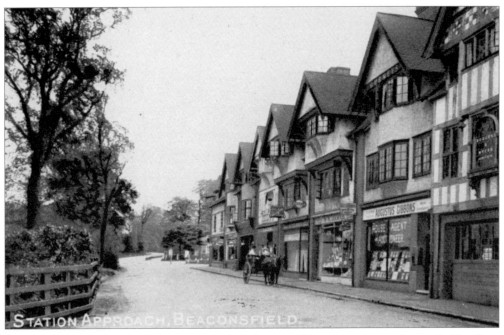

One of the first two parades of shops to be built in the New Town, this is Station Approach. The shops have changed, but the first-storey windows and gables look the same today. Charles Holden, the architect, who shared an office in this block on the extreme right, carved the date 1910 in the woodwork.

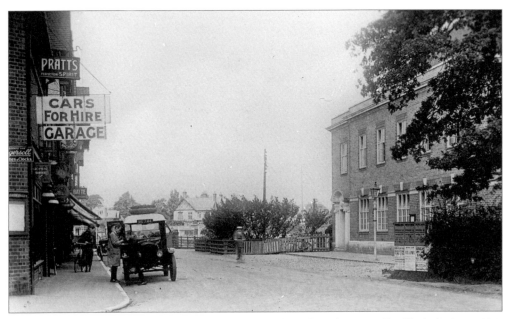

On the left is Station Garage, run by Mayne & Sons. On the right is the post office block, built in 1926. Beyond is the fence around the front garden of the station-master's house.

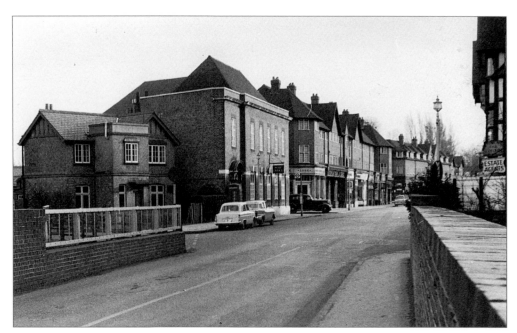

A view over the railway bridge looking south. The station-master's house on the left was demolished in the 1950s. That corner site is now occupied by Boot's the Chemist. The estate agent on the right was for many years A.C. Frost and Co. There was still a pavement on only one side of the bridge, perhaps because there was so little traffic.

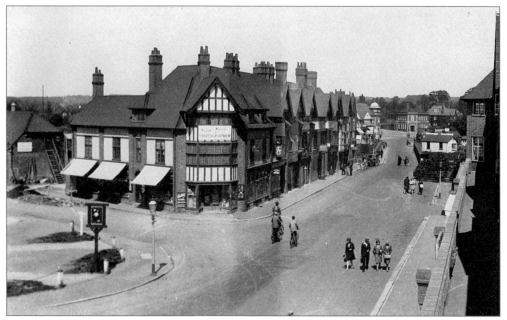

This 1930s view must have been taken from the balcony in front of the Highway Court flats. On the corner of Gregories Road was Mayne's, the ironmongers. One could stroll in the road in those days, even in the New Town.

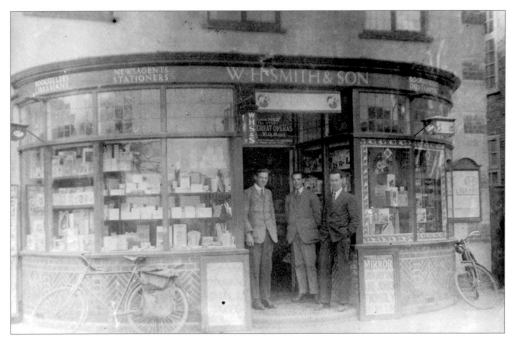

In the early 1930s W.H. Smith & Son occupied these premises on the corner between Gregories Road and
Burkes Road before moving to its present position.

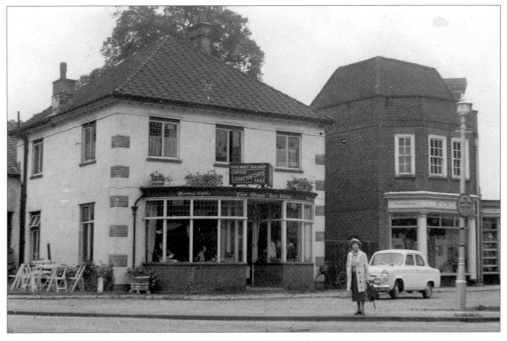

Later in the 1930s Mrs Henriques opened the Fiveways Café in the same premises. Next door is Crome's,
the house furnishers. The large apartment block named Cardain House, built in 1965, with shops on the
ground floor, now occupies this site.

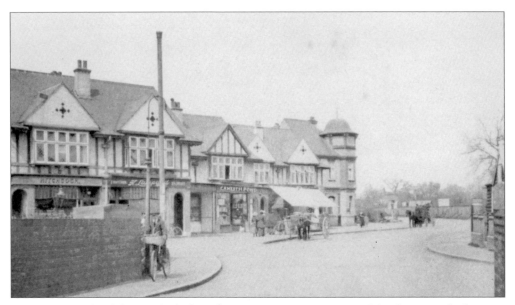

The second parade of shops to be built in the New Town, *c.* 1910. One of the shops was the first post office, which remained here until the new purpose-built block was erected across the bridge.

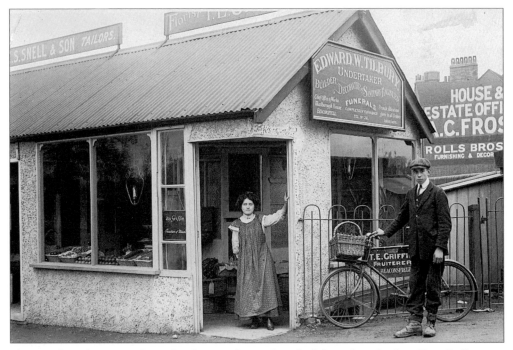

The very first shops were housed in huts at the north end of the railway bridge. Tom Griffin grew cucumbers and tomatoes for sale, the shop assistant being his daughter Margaret. Other businesses took the opportunity to advertise here – Edward Tilbury, builder and funeral director, and music teacher Mrs Griffin.

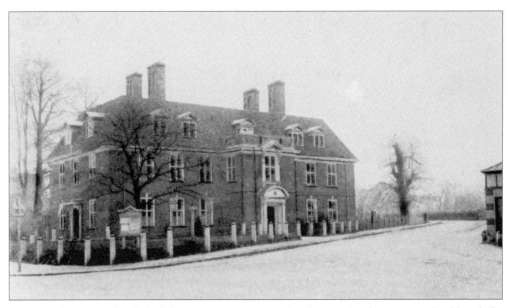

This is the first Council Hall, built by 1919 on the corner of Burkes Road and Station Road. Although the ground floor has been altered and shop fronts added, the main doorway and dormer windows still remain.

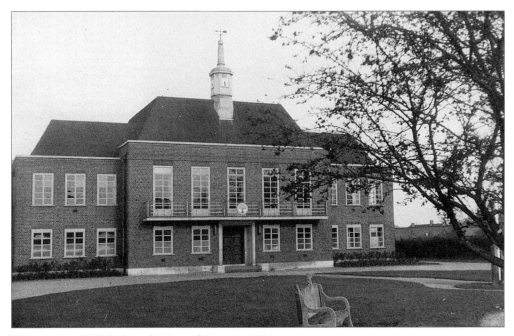

The new Town Hall, built on the Council Green in 1936.

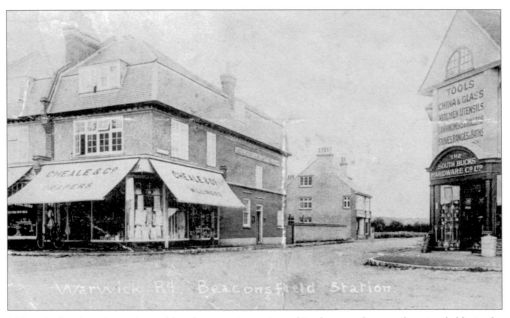

Although the shops have changed hands many times since this photograph was taken (probably in the 1920s), the buildings at the junction of Penn Road and Warwick Road are still much the same today.

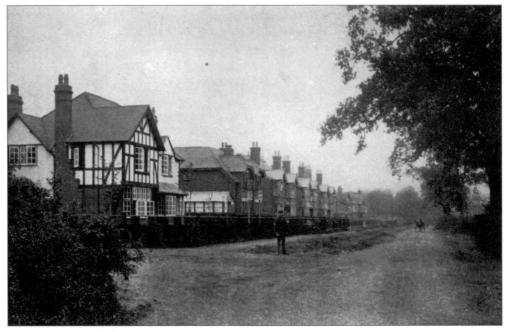

The corner of Ledborough Lane and Penn Road now has a block of flats, Harescombe Court, and decidedly more traffic than when this photograph was taken before the First World War.

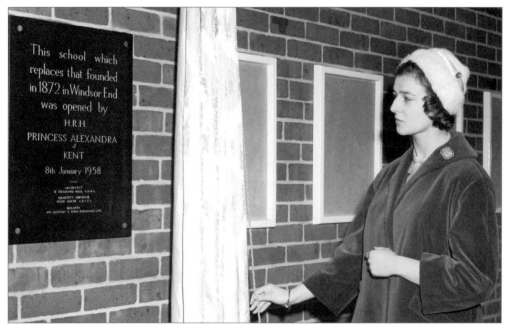

Princess Alexandra of Kent unveiling a plaque at the opening of the new Maxwell Road Church of
England Primary School, 8 January 1958.

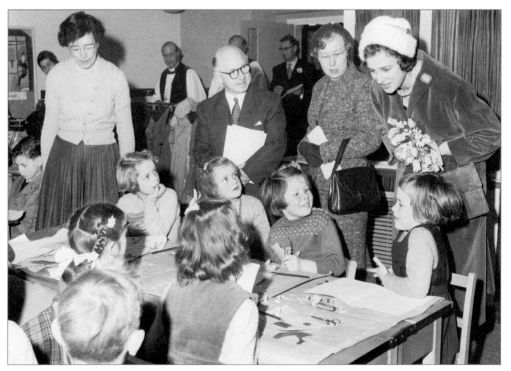

Headmaster Frank Goodman and deputy head Peggy Steen show the Princess around one of the
classrooms.

PEOPLE AT WORK

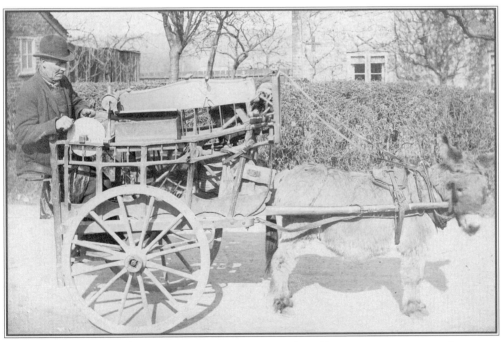

During the early years of this century, and up to the Second World War, various itinerant tradesmen were a feature of Beaconsfield. This photograph, taken in about 1930, shows old Goff, the well-known knife-grinder, with his donkey cart. His grinding wheel is worked by foot-power.

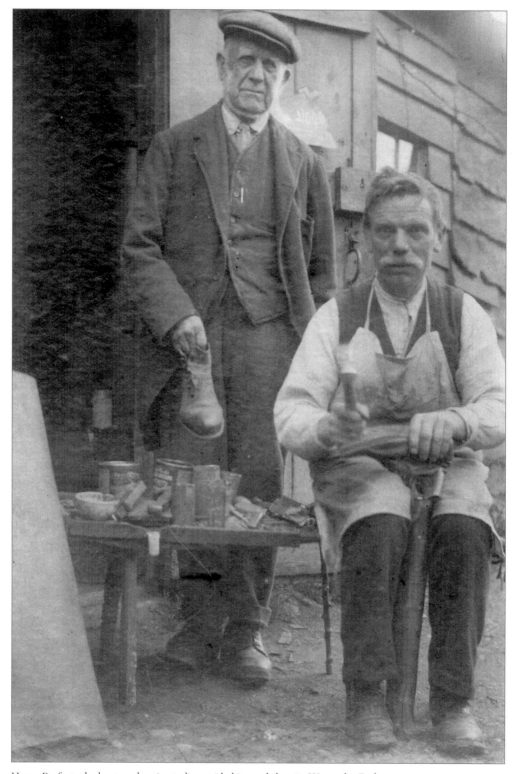

Harry Perfect, the boot-maker (seated) outside his workshop in Wycombe End.

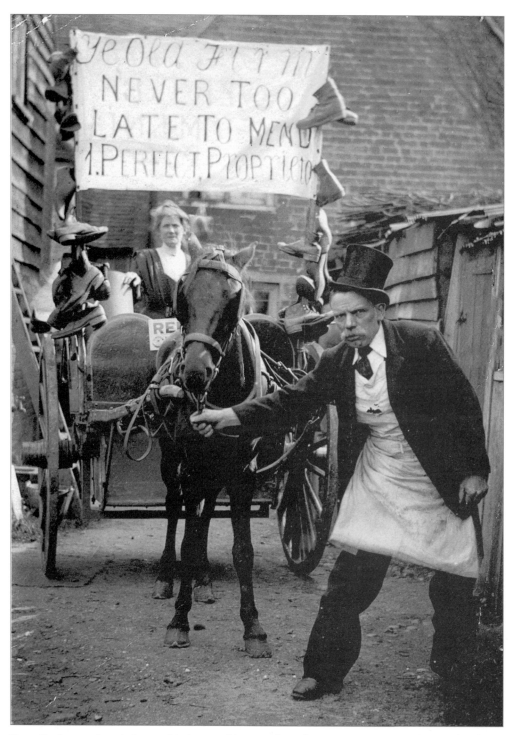

Harry Perfect, ready to bring out his decorated horse and cart for a procession. His wife Hannah is sitting at the back. Notice the boots tied at the side of the banner, which reads 'Ye Old Firm – Never too Late to Mend'.

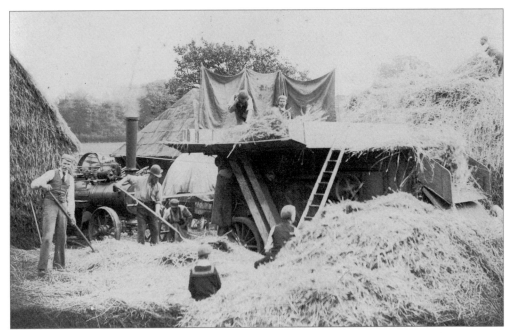

Augustus Day's photograph of haymaking at Wiggenton Farm, probably before the First World War.

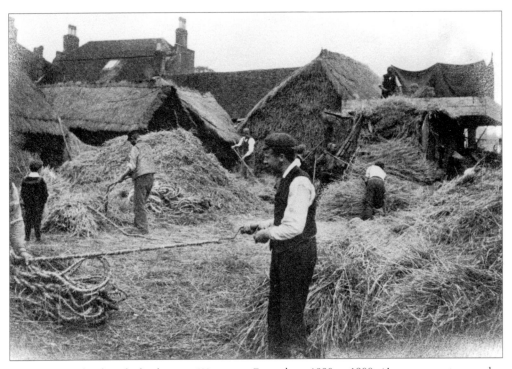

This picture is also described as being at Wiggenton Farm about 1890 or 1900. (A more recent owner has changed the spelling to Widgenton to clarify the pronunciation.) The figure in the foreground is making straw rope and the finished product is lying on the ground to the left.

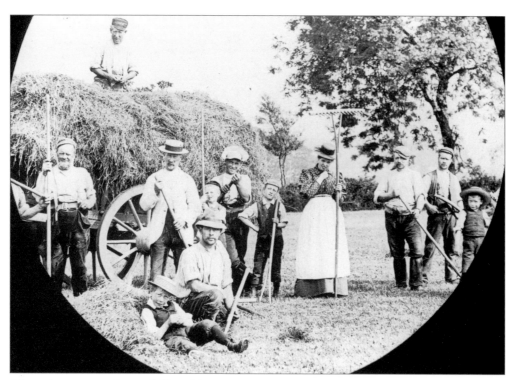

A haymaking scene at Beaconsfield in 1895.

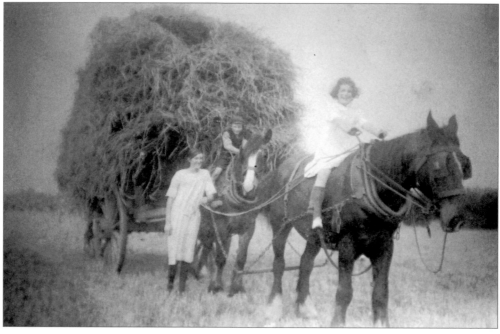

Overs Farm in the 1920s. On the left is Mary Pitcher who looked after her father and siblings at the farm. At centre is Mary's brother, Stephen.

The cherry industry was flourishing when Job Wooster planted this orchard at Seeleys Farm early in the century. Skilled fruit-pickers took time off from their regular jobs to harvest the tons of cherries and up to sixty people were employed at Seeleys alone.

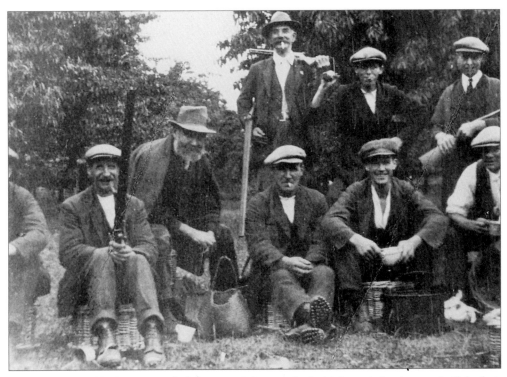

Cherry pickers and bird-scarers with their guns. Unfortunately the birds needed to be scared off the fruit in the early hours of the morning, which did not please local residents trying to sleep. Labour costs and railway transport difficulties helped to bring an end to the cherry industry.

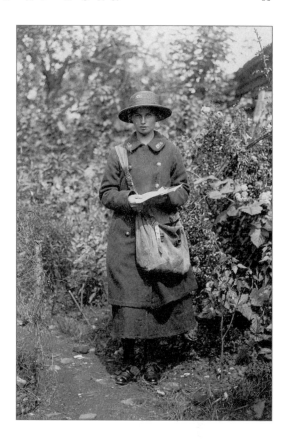

Ada Benyon was a postwoman during the First
World War. She does not appear to have had a
bicycle for her delivery round.

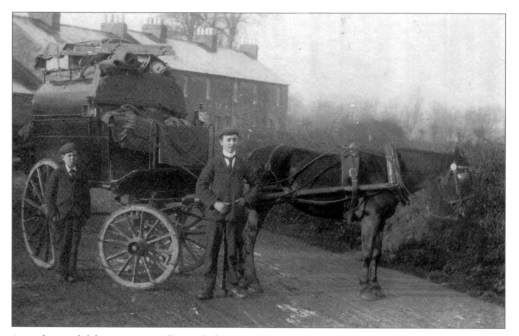

An early postal delivery van in Mill Lane before 1900.

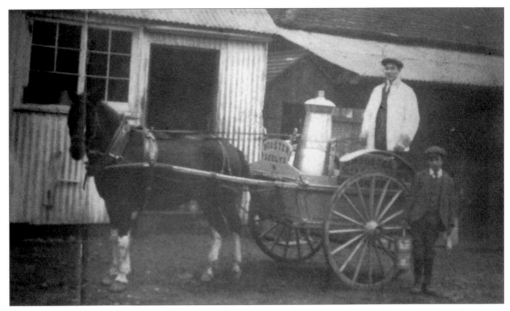

A milk delivery cart from Seeleys Farm probably in the 1920s. The name of Job Wooster, the farmer, is now remembered in Wooster Road on Seeleys housing estate.

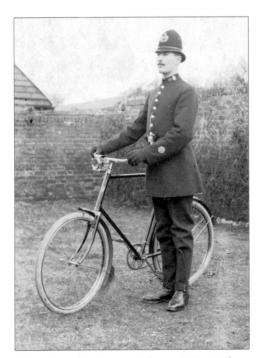

Police Constable George Kirby, *c.* 1914. He later became an Inspector, serving in Beaconsfield until 1920. He then transferred to High Wycombe, and afterwards became Deputy Chief Constable of Buckinghamshire.

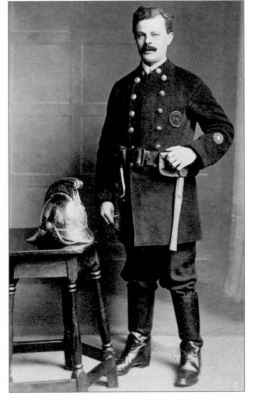

Fireman Albert Lake resplendent in his uniform.

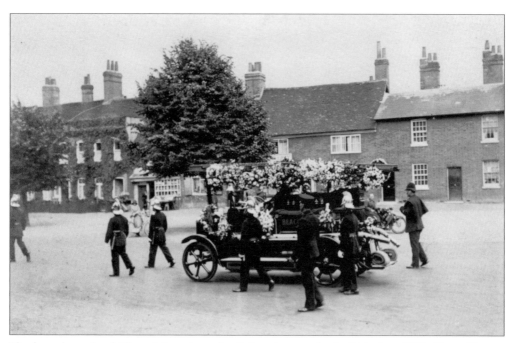

The funeral parade of Albert Lake, who sadly died at the age of only 38 in June 1925. The coffin was conveyed to the parish church on the Beaconsfield fire engine, which was decorated with flowers for use as a hearse. This was the first 'official' funeral of a fireman in Beaconsfield.

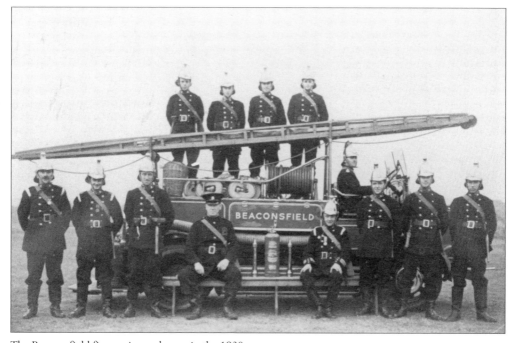

The Beaconsfield fire engine and crew in the 1930s.

These servants outside Butler's Court are taking a tea-break while helping to clear up in the aftermath of a fire which damaged the house in 1934. On the left is Mr Taylor, the chauffeur, with the gardener.

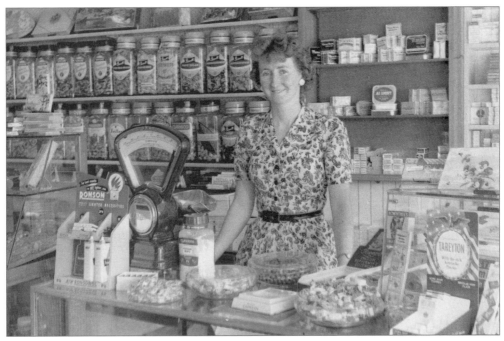

This picture, dating from 1952, brings back happy memories of the old-fashioned sweetshop, Poppies, which used to be at no. 6 The Highway, where a florist's is now. Mrs Dancer is behind the counter.

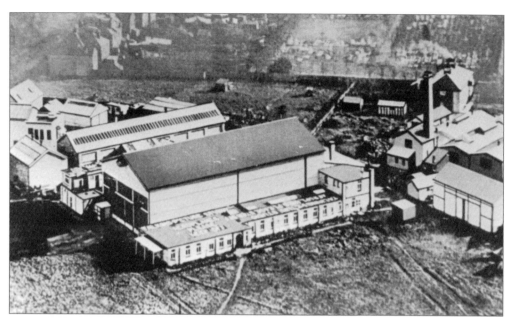

The Film Studios in Station Road started in 1921. Filming continued on the site until 1966. On the roof in the centre were painted in large letters the words: TALKING PICTURE STUDIOS AEROPLANES PLEASE KEEP OFF. The words are repeated the other way up for the benefit of pilots flying in the opposite direction.

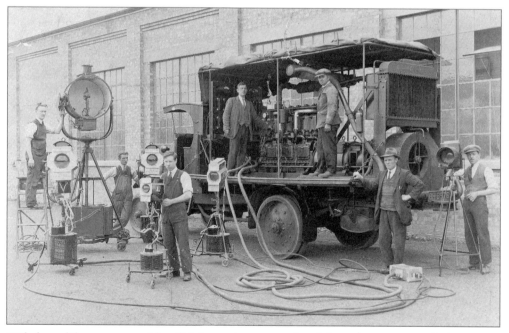

With the mobile generator and floodlighting equipment are (from left) Arthur Timpson, Charlie Evermy, Bert Piercy, Ernest Brown (in charge), 'Bronco' Hudson, Bill Bigsworth, -?-. When required, which was often, the technicians were called upon to take part in crowd scenes.

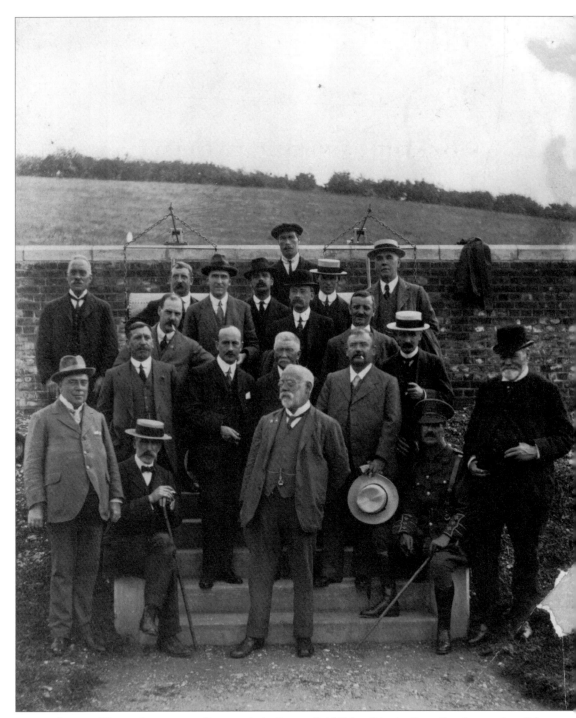

Chairman Thomas Lane (centre, front) with the Beaconsfield Urban District Council at the opening of the Holtspur Sewage Farm in Riding Lane just before the First World War. The figure in military uniform is Harry Sergeant, Surveyor to the Council.

SPORT AND LEISURE

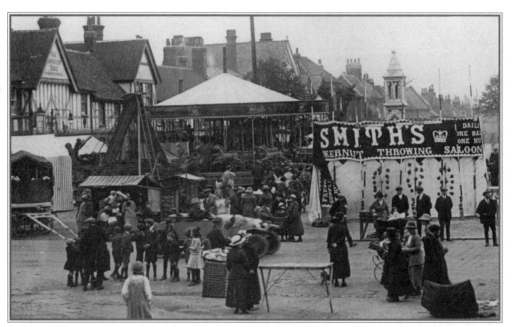

An important date in Beaconsfield's year is 10 May, the day of the fair. In former times cattle sales were held, but nowadays swings, roundabouts, a helter-skelter and a big wheel are set up in the four Ends. Stall holders have documents dating back to the nineteenth century showing the pitches where their forebears had their stalls. In May 1969 Beaconsfield celebrated the 700th Anniversary of the Fair Charter.

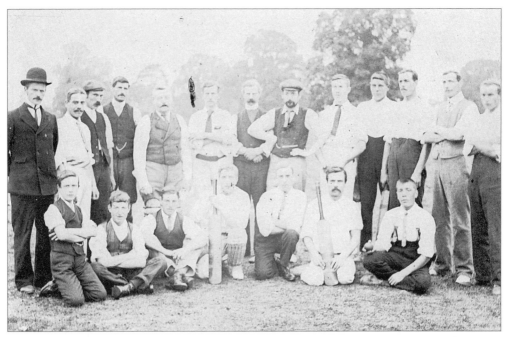

A group of Beaconsfield cricketers at the end of the last century. Cricket has been played here from early in the eighteenth century, and the club was formed in 1825. From 1871 White Hart Meadow, now Horseshoe Crescent, was used, and later the Wilton Park ground where the club still flourishes.

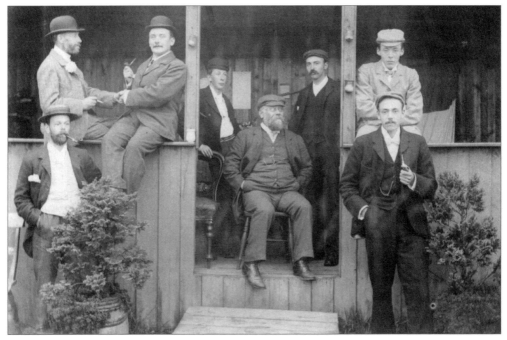

This group is pictured at the Cricket Pavilion, c. 1900. They include Fred Myers (front left), Thomas Lane (centre), Rowland Perryman (on the ledge, with pipe) and Archibald Cheale (front right).

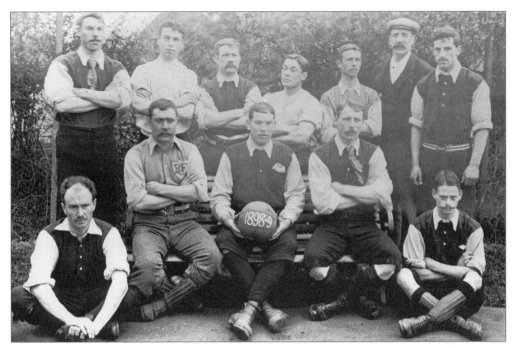

The town's first football club was Beaconsfield United, formed between 1860 and 1870. Their colours were black and yellow, and they played at Holloways Park on the old Windsor Road. Here is the team in the 1898/99 season. Notice the men's breeches and long socks; two of them have shin-guards.

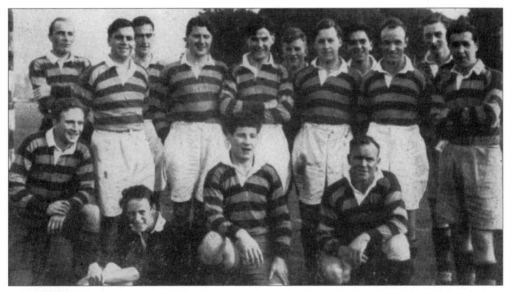

Beaconsfield Rugby Club was founded in 1952 and played their first full season in Coronation year, 1953. The club's ground was in Oak Lodge Meadow, Hedgerley Lane, and their headquarters were at the White Horse in London End. The players wore green and gold jerseys with a beech leaf crest, white shorts, and green and gold socks. The picture shows the team that played its first game against Windsor Extra A. The result was a sad loss for Beaconsfield: 21–3.

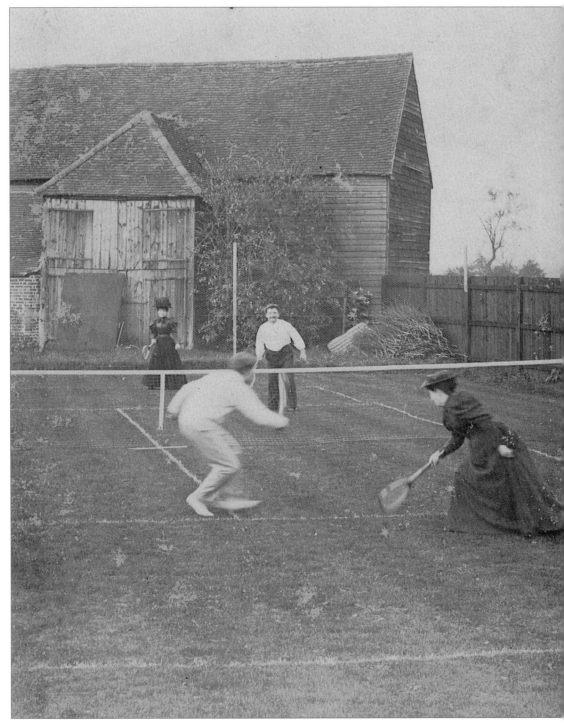

A game of tennis in White Hart Meadow, c. 1896. No leisure-wear in those days! Headgear was essential. One wonders whether women secretly loosened their stays. Facing the camera are Maude Day and Rowland Perryman, and in front Arthur Baker and his wife. Arthur Baker was the schoolmaster who signed the certificate shown on page 11.

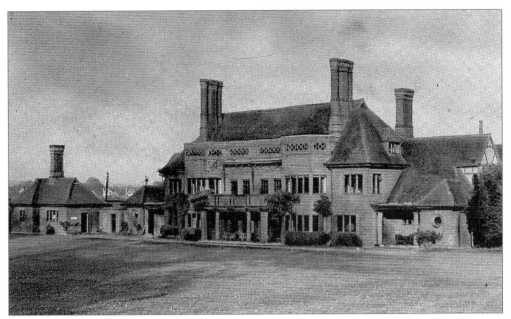

William Baring Du Pre formed the Wilton Park Golf Club in 1902. This was a nine-hole course in the grounds of the Park, but in 1913 he had a new eighteen-hole course constructed and the name was changed to Beaconsfield Golf Club. The clubhouse pictured here, built in 1914, is familiar to all train passengers travelling between Beaconsfield and Gerrards Cross. When the railway line was being planned he arranged for a halt to be sited at Seer Green and the clubhouse was built alongside. Between 1915 and 1918 the halt was called Beaconsfield Golf Links.

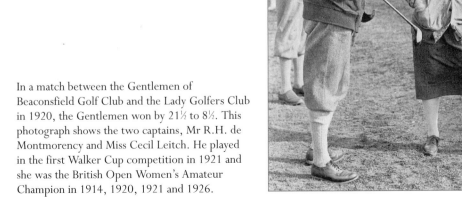

In a match between the Gentlemen of Beaconsfield Golf Club and the Lady Golfers Club in 1920, the Gentlemen won by 21½ to 8½. This photograph shows the two captains, Mr R.H. de Montmorency and Miss Cecil Leitch. He played in the first Walker Cup competition in 1921 and she was the British Open Women's Amateur Champion in 1914, 1920, 1921 and 1926.

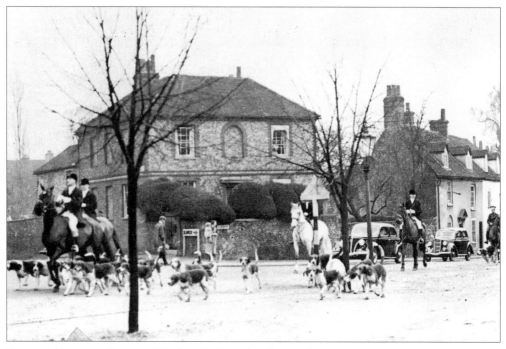

Horses and hounds gathering in Windsor End for a drag-hunt in the 1930s.

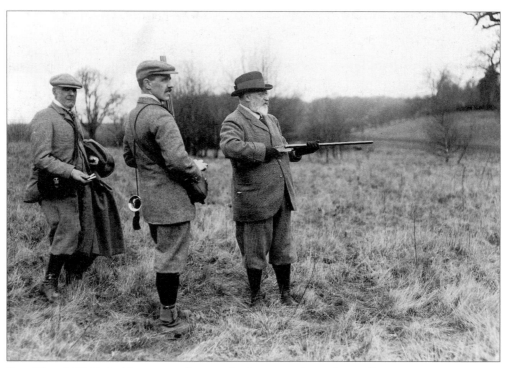

King Edward VII, flanked by two gamekeepers, has his gun at the ready at Hall Barn in January 1910. He was regarded as one of the best shots in the country.

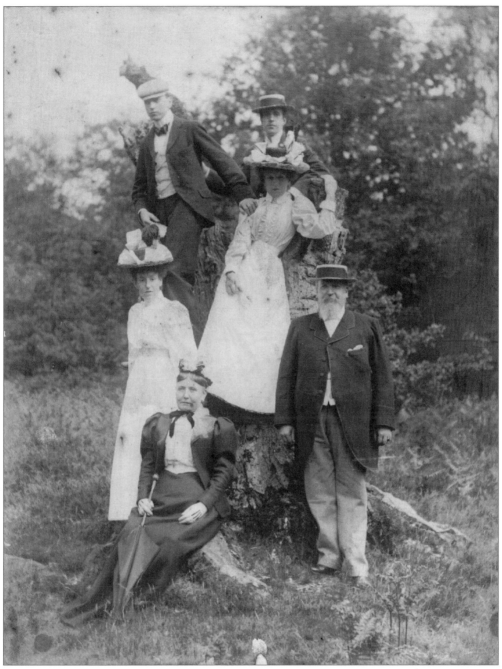

Augustus Day took this photograph of his family in Wilton Park in 1895. He was the father of Kathleen (*see* title page), and his siblings were Henry (top left), Frederick (top right), Maude (centre right), and Florence (centre left). At the front are his parents, Sarah Jane and Uriah. The Day's Stores building features in several photographs in this book.

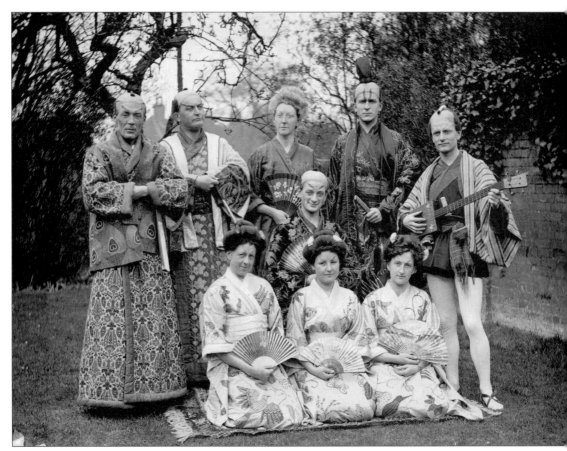

Early in this century enthusiastic groups of amateurs gave dramatic and operatic performances in Beaconsfield and the tradition is maintained to this day. The first production was 'The Mikado' in 1910. The New Hall mentioned in the programme opposite was Burnham Hall in Malthouse Square. Notice that carriages should arrive at 10.45. On the back page were given times of 'Special Trains' for High Wycombe and Marylebone. Ladies were 'requested to remove their hats during the performance'. Charles Holden (with mandolin) was an architect with an office in Station Approach. The *South Bucks Standard* was pleased to give the production 'unstinted praise in every particular'.

BEACONSFIELD.

IN THE NEW HALL TUESDAY, WEDNESDAY & THURSDAY,
(By kind permission of Lord Burnham.) *26th, 27th, 28th April, 1910, at 8.*

THE MIKADO

Gilbert. OR, THE TOWN OF TITIPU. *Sullivan.*

The Characters:

THE MIKADO OF JAPAN...	MR. L. C. HOLLOWAY.
NANKI POO *His Son* ...	MR. W. F. C. HOLDEN.
KO KO *Lord High Executioner* MR. J. G. BURGESS.
POOH BAH ... *Lord High Everything Else* ...	MR. M. JOHNSON.
PISH TUSH ⎫ ... *Noble Lords* ...	⎰ MR. L. W. MYERS.
GO TO ⎭	⎱ MR. E. B. GROVES.
KO KO'S SWORDBEARER...	MR. G. H. SMITH.
YUM YUM ⎫	⎛ MISS F. M. FAY.
PITTI SING ⎬ ... *Wards of Koko* ...	⎨ MRS. HERBERT BURGESS.
PEEP BO ⎭	⎝ MISS R. M. SILVERLOCK.
KATISHAMRS. BURRAGE.

Chorus of School Girls and Nobles:

MRS. BELBIN.	MISS McGOWAN.	MISS WILLIAMS.	MR. CHEALE.	MR. WHITE.
MRS. DAVIS.	MISS SCHMIDT.	MISS WINGROVE.	MR. A. G. GROVES.	MR. WINGROVE.
MRS. GRICE.	MISS SMYTHE.		MR. HANCOCK.	MR. WORLEY.
MRS. SHILCOCK.	MISS WESTCOTT.		MR. C. H. WATSON.	

The Scene:

COURTYARD OF KOKO'S OFFICIAL RESIDENCE.

Interval of Ten Minutes between Acts I & II.

Conductor. *Stage Manager.*
MR. HERBERT BURGESS. MR. W. F. C. HOLDEN.

Costumes by J. B. Simmons & Co.

The Performances by permission of Mrs. D'Oyly Carte.

Carriages 10.45.

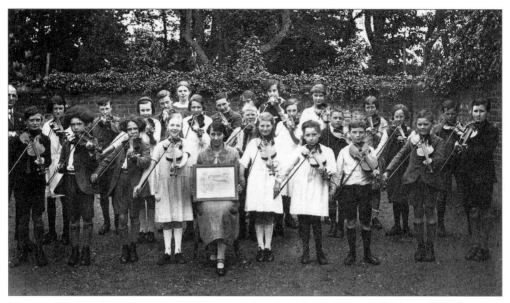

Miss Cordelia Wright at the centre of the Beaconsfield School Orchestra, probably in the early 1920s.
Miss Wright is holding a framed version of a certificate similar to the one below. She taught at the school
in Windsor End from 1910 until 1939 when she retired.

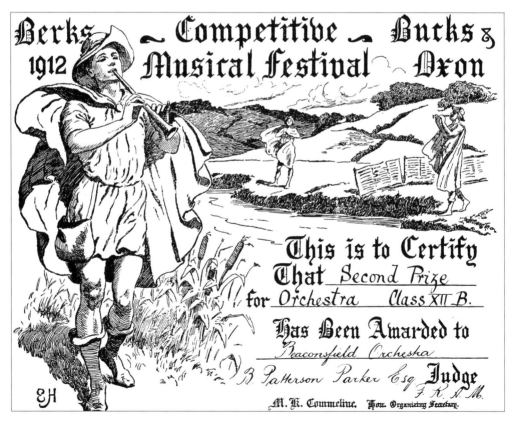

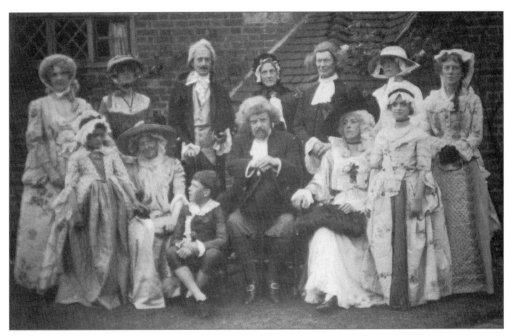

This picture is from an album of photographs taken at the Old English Fayre in aid of the Red Cross in June 1918. It was a lavish two-day event in Windsor End, which was fenced off for the duration. At the centre is the author G.K. Chesterton as Dr Johnson with Mrs Chesterton behind him. He lived in Beaconsfield from 1909 until his death in 1936, and took part in many local activities.

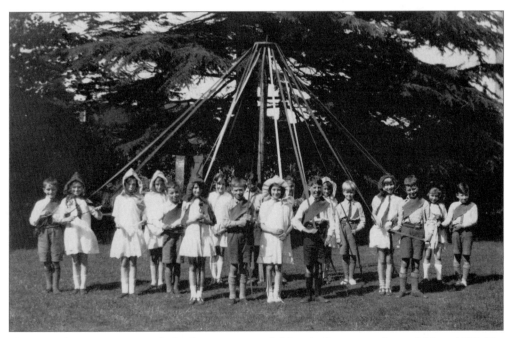

This Maypole Dance was part of a fund-raising concert held in the Rectory garden on 26 June 1930. The children of the Church of England School were taught the dance by Miss Young. Over £100 was raised.

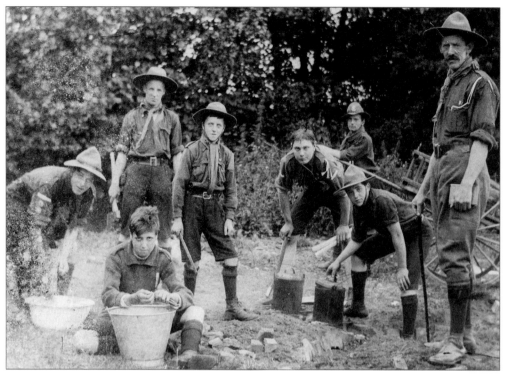

Boy Scouts at camp with Mr Baily Gibson, the Scoutmaster, on the right. He was a solicitor with premises in the New Town and his firm is still in business. The 1st Beaconsfield Scout Company was formed in 1910.

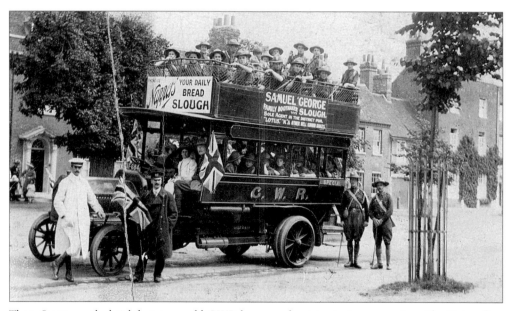

These Scouts, packed tightly into an old GWR bus, are about to start on an outing. The Union flags suggest a patriotic celebration, the date being before 1914.

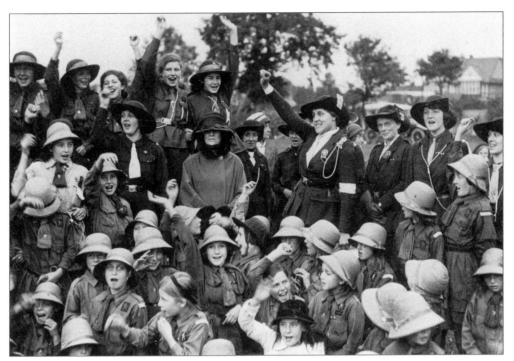

A Girl Guide and Brownie rally in the grounds of Hall Barn in 1922. At centre (with her hat over her eyes) is Lady Burnham. Leading the cheering is the Chief Guide, Lady Baden Powell. On her left is Kathleen Woozley, the original Brown Owl of the 1st Beaconsfield Brownie pack. Notice the straw hats Brownies wore in those days.

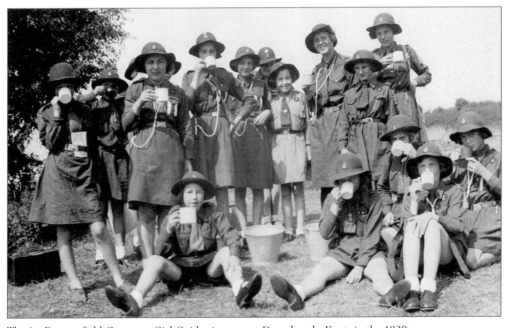

The 1st Beaconsfield Company Girl Guides in camp at Dymchurch, Kent, in the 1930s.

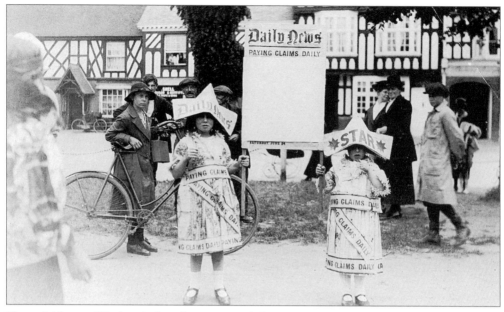

These children in Windsor End in the 1920s are helping to promote a newspaper competition. Mrs Benyon, whose family ran the newsagents in Wycombe End, supplied this photograph but does not know the purpose of the promotion.

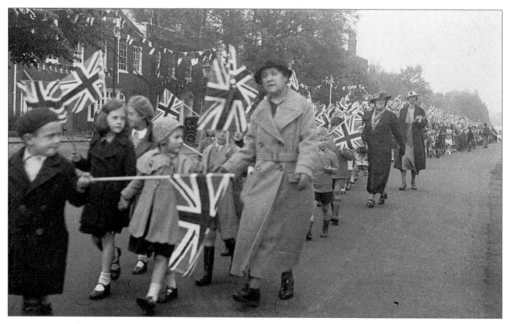

A procession along London End by schoolchildren celebrating the Coronation of King George VI in May 1937. The teachers are (left to right) Mrs Steadman, Mrs Forrest and Miss Cordelia Wright.

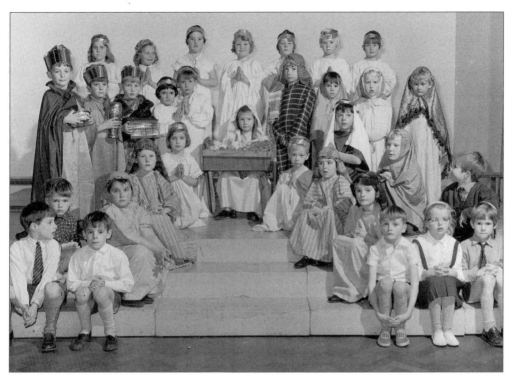

A nativity play at the primary school in Maxwell Road in 1966.

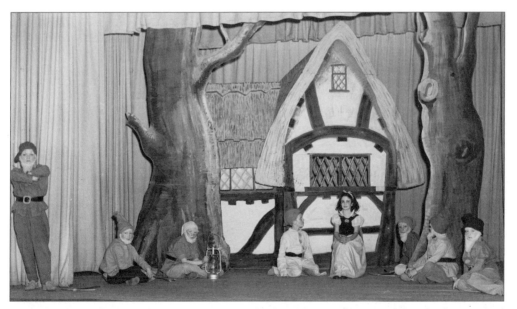

Mr Tame, the headmaster of Holtspur Primary School and later Holtspur Middle School, wrote and produced a successful pantomime annually from 1952 to 1981, with pupils in their final year taking part. 'Snow White' was the production in 1957, with Anna Best in the lead role and (left to right), J. Rivers, A. Maskell, A. King, N. Cornford, T. Campion, P. Ray and C. Smith as the dwarves.

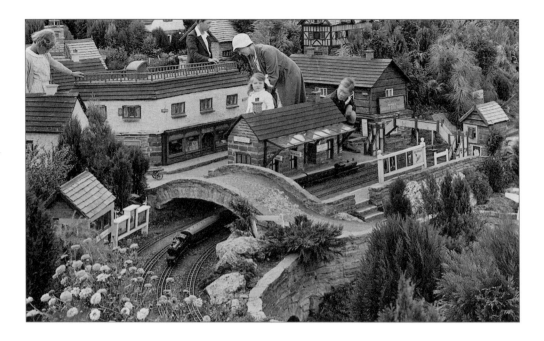

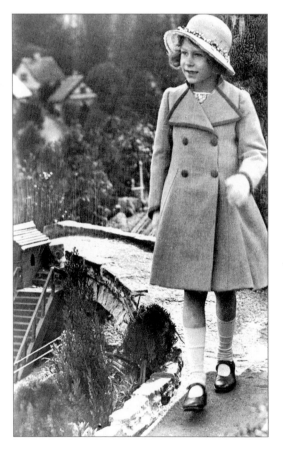

A nationally known and ever-popular feature of the New Town is the model village Bekonscot, which is open from March to October each year. It was started in 1929 on two acres of land in Warwick Road by Mr Rowland Callingham, assisted by Mr Berry and Mr Clark. Mr Callingham was a model railway enthusiast, and the village boasts a comprehensive working railway system with realistic stations, bridges and miniature trains. There is a race course, a church (with organ playing), an aerodrome, a port with shipping, a sports field and much more. Princess Elizabeth came here as a birthday treat when she was eight, and in more recent times the Princes William and Harry have honoured the village with a visit.

WARTIME

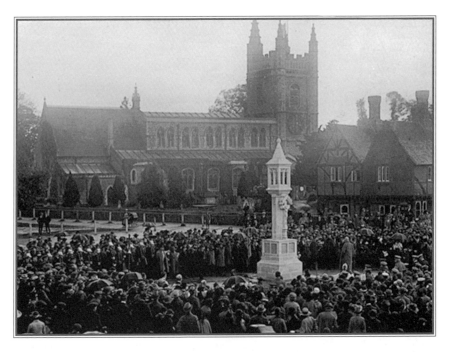

'Let Light Perpetual Shine Upon Them.' The memorial to the dead of the First World War
was unveiled by Field Marshal Lord Grenfell, whose nephew fell gaining the first Victoria
Cross of the war. The ceremony took place in May 1921 when the memorial was near the
centre of the four Ends. It was moved to its present site on The Green in 1934 because of
the increasing traffic. It is one of the few memorials in the country that contains
a perpetual flame.

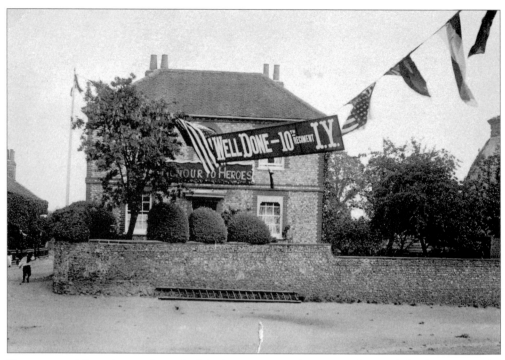

The capture of Pretoria near the end of the Boer War was the occasion for much local rejoicing. This display outside Edith Lodge in Windsor End on 21 June 1901 was in honour of the 10th Regiment Imperial Yeomanry, commanded by Colonel W.A.W. Lawson DSO, later the third Lord Burnham.

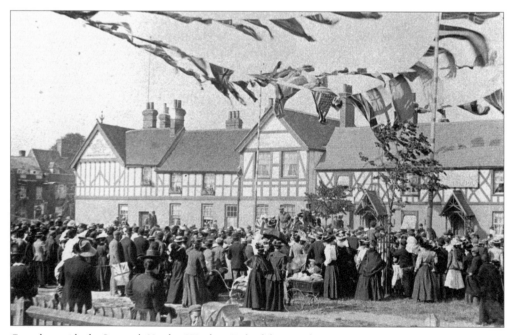

Crowds outside the Saracen's Head in Windsor End celebrating the same occasion.

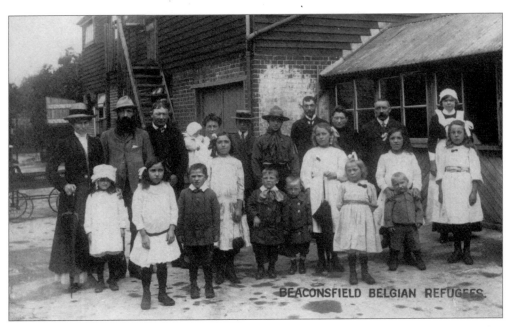

These Belgian refugees, photographed in the backyard of the Convalescent Home, arrived in October 1914, having abandoned their destroyed homes and fled from the advancing Germans. Altogether eighty-nine people passed through the Home, and some were housed there until lodgings could be found for them. Appeals were made locally for funds to support the refugees. The Belgians spoke only Flemish, but there was a Flemish refugee priest lodging at Penn who came to Beaconsfield to say Mass for the Belgians in a room at the Railway Hotel.

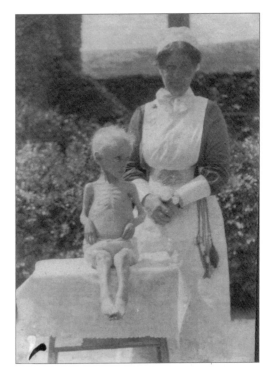

This starving child with swollen belly and matchstick limbs is the victim not of some far-flung modern disaster but of the First World War in England. This young patient at the Convalescent Home in 1917 is one of many whose fathers were fighting or perhaps missing or dead, and whose mothers could not afford to feed them. There was no Social Security in those days.

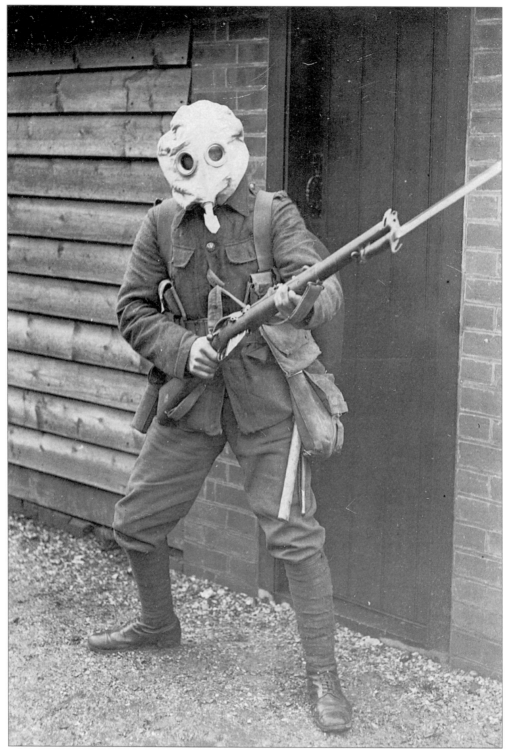

Here is John Harry Perfect with bayonet and gas-mask. He served in the Oxfordshire and Buckinghamshire Light Infantry during the First World War.

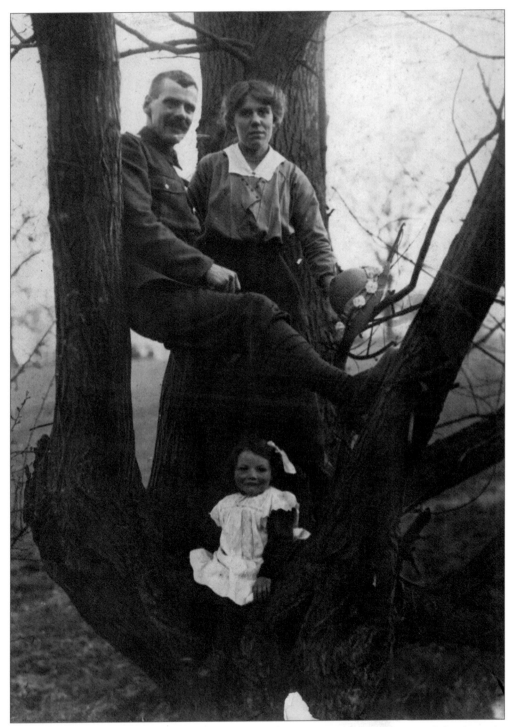

On leave from the Army is Will Perfect, seen here with his sister Charlotte and Will's small daughter Lily. This photograph was taken on the Hall Barn estate in 1918. Charlotte Perfect was the grandmother of Dick Smith, the present Town Crier.

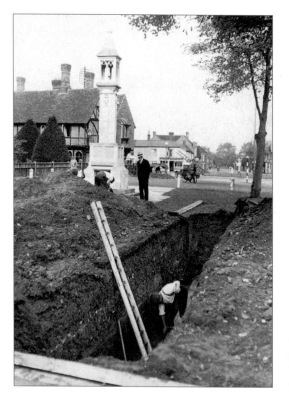

On 3 September 1939 the Second World War started, and this trench on The Green in Windsor End was one of many dug at this time.

Sandbags protecting the front windows of the police station in Windsor End at the beginning of the Second World War in 1939.

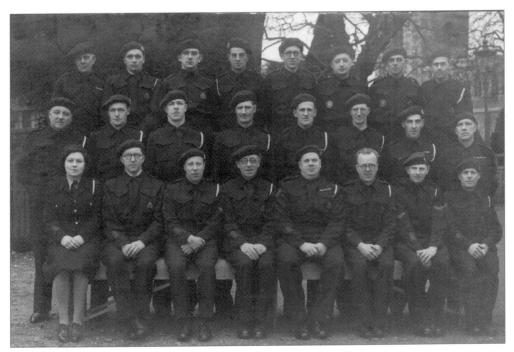

Beaconsfield Civil Defence Rescue Service. Mr Bert Piercy is third from left in the front row.

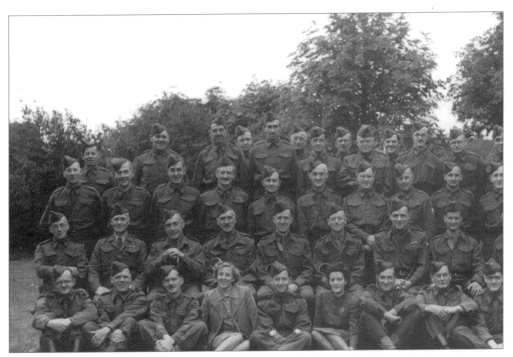

No. 4 Platoon, 'B' Coy, 5th Bucks Battalion Home Guard (Coy HQ, Staff, Signals, Intelligence, Transport, Range & Ammunition Sections) 1944 – otherwise Beaconsfield's own 'Dad's Army'. In the centre of the second row from the front is Major G.L. Millington; fourth from the left in the same row is Capt. L.E. Peppiatt MC and Bar.

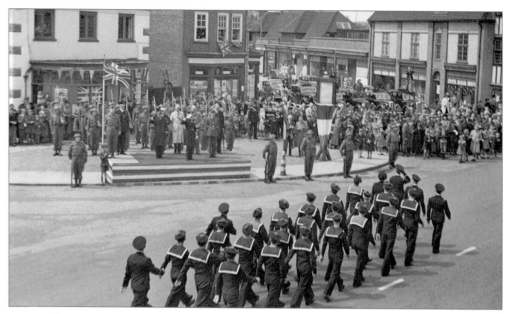

Weapons for War Week – a National Savings Drive during the last war, in 1941 or 1942. This picture shows the march-past of a contingent of Free French sailors, the salute being taken by Admiral Wardle at the corner of Gregories Road and Station Road, with the Fiveways Café behind the dignitaries.

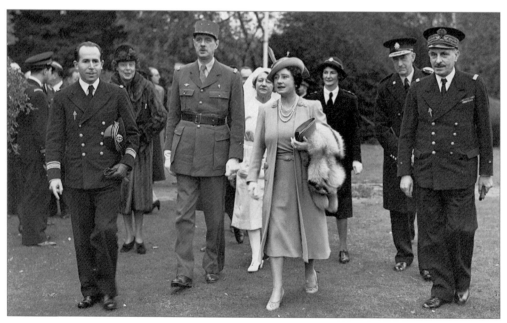

Queen Elizabeth (now the Queen Mother) and General de Gaulle visiting the Free French naval hospital that was housed in Butler's Court during the Second World War. Left to right: Captain Nublat, the Queen's Lady-in-Waiting, General De Gaulle, the Matron, the Queen, Commandant Mrs Burnett Brown, -?-, and Admiral Musselier. The visit took place in 1944.

AROUND BEACONSFIELD

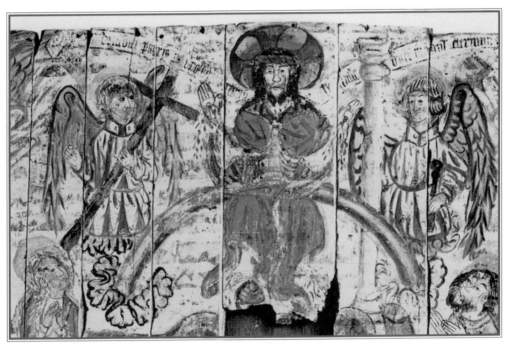

A detail from the central portion of the rare fifteenth-century painting of the 'Doom' or Last Judgement in Penn Church.

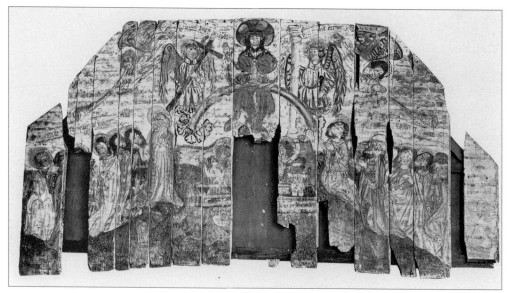

The medieval painting of the 'Doom' may be seen over the eighteenth-century chancel arch in Penn Church. Painted on oak boards in the 1400s, it was repainted about a century later and cut to fit its present position. High up and forgotten, hidden under a coat of whitewash, the panel survived the Reformation, the Commonwealth and the destruction of the chancel by fire. In 1938 the boards were thrown on to a rubbish tip and it was only when the whitewash was partly washed away by rain that the painting was revealed. The 'Doom' was restored by archivist Mr Clive Rouse of Gerrards Cross.

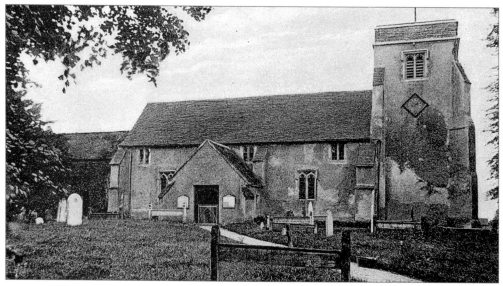

Penn Church viewed from Church Road. An ancient building with a foundation stone dated 1177, the church has been added to over the centuries. There is a large Penn family vault inside the church and the Penn family pew is adjacent to the pulpit. This photograph dates from about 1900, before the tower was restored and the parapet rebuilt in 1903. This work was funded by £500 raised by the citizens of Philadelphia, USA, in honour of William Penn, the founder of Pennsylvania.

The Crown Inn at Penn dates from the seventeenth century. In the foreground were once the village stocks and two trees known as the Stocks Elms. One elm tree survives as a hollow trunk.

Knotty Green Farmhouse, built in about 1790, once stood on the corner of Finch Lane at Knotty Green. The Wooster family farmed here and are seen with friends in their pony-trap in 1910. The house was demolished in 1960.

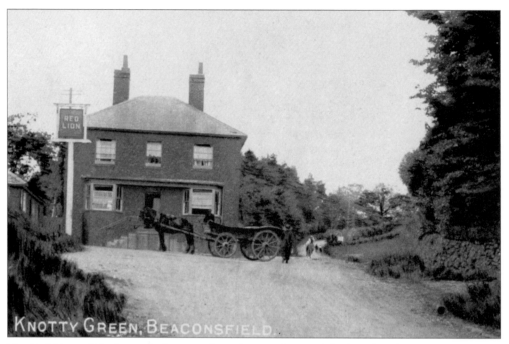

The Red Lion still looks much the same from the outside as it did when this photograph was taken, probably in the early years of this century.

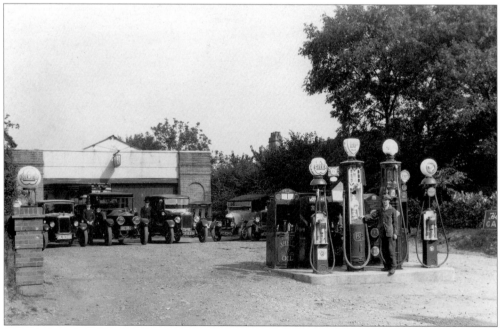

Knotty Green Garage, opposite the Red Lion, was known as Hallett's Garage when this photograph was taken in 1931. Chauffeur Harry Beardsall is standing by the Rolls-Royce, Doug Griffiths by the Austin, and Teddy Iles at the pumps.

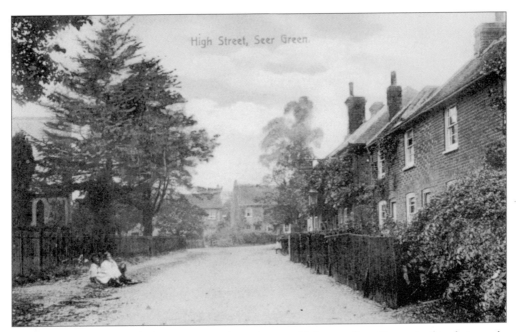

The church on the left and the cottages on the right are still there at Seer Green. In this photograph, probably in the 1920s, the road is not made up and is entirely free of traffic, allowing children to play or sit and dream.

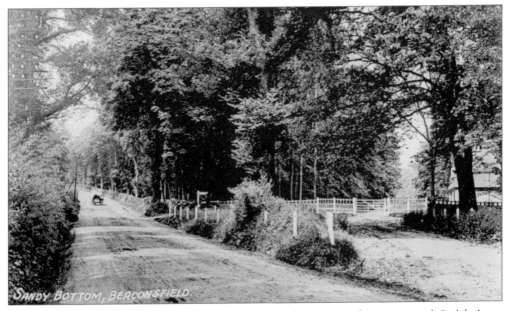

The road between Gerrards Cross and Beaconsfield – now the A40 – at the junction with Potkiln Lane. The gate just along the lane was the eastern boundary of the Wilton Park estate. The area was known as Sandy Bottom. When Josias Du Pre came to Wilton Park in about 1770, the main road from London to Oxford ran through the estate until he diverted it to its present route. A horse and cart could plod its way in the middle of the road in 1910.

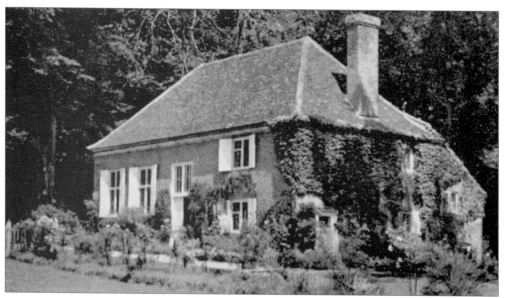

The famous Friends' Meeting House, built in 1688, near Jordans Farm. William Penn (1644–1714) contributed to the building of the Meeting House and worshipped there. He particularly wished to be buried in the graveyard among his fellow Quakers. His simple grave, with its plain stone identical to those around it, is visited each year by many Americans, particularly from Pennsylvania, the state founded by Penn, who was its first governor.

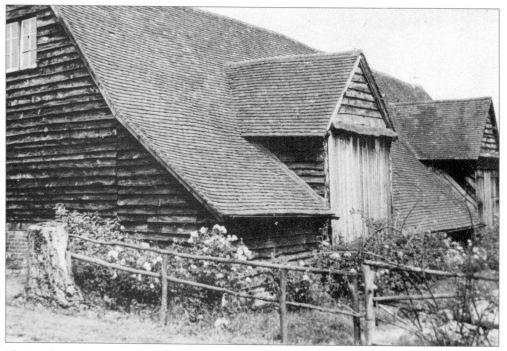

The Mayflower Barn at Jordans, reputed to be built from the timbers of the Mayflower, the ship that carried the Pilgrim Fathers to America in 1620.

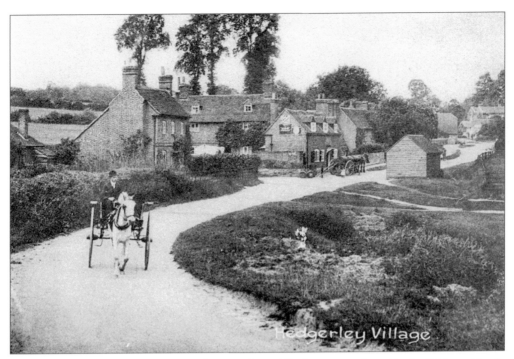

Village Lane in Hedgerley. The horse and cart in the middle distance stand outside the Brickmould pub. Brickmaking was an important trade in the village. Bricks produced in Hedgerley were prized for their heat-resistant qualities, which resulted from the high sand content in the local clay. Brick and tile making continued until the last works closed in 1936. Only one building from this 1910 scene remains today, the smithy on the left.

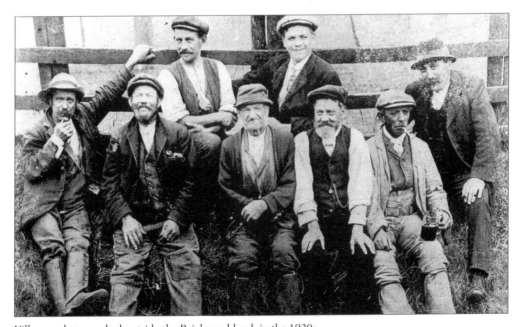

Villagers photographed outside the Brickmould pub in the 1920s.

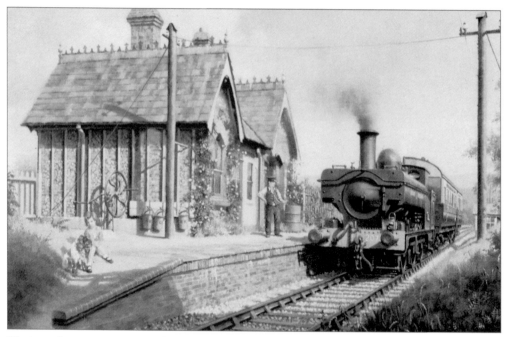

Wooburn Green station was on the branch line from Maidenhead to High Wycombe. The line was built using Brunel's broad gauge in 1854, and was closed under the 'Beeching axe' in the 1960s. The station was the nearest to Beaconsfield until the completion of the railway through the New Town in 1906.

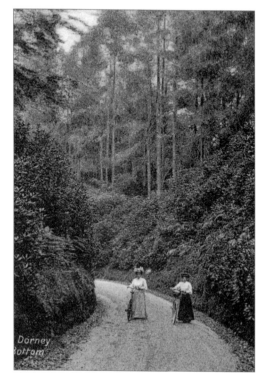

The road between Beaconsfield and Slough dips into a valley known as Dorney Bottom. The slope is steep enough for cyclists like these two women to have to dismount and walk two abreast on the narrow road, now the busy and much-widened A355. The photograph dates from about 1910.

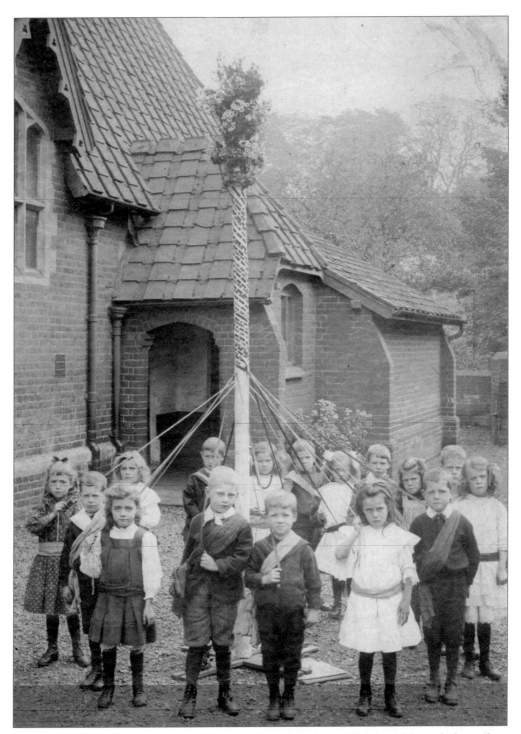

Pupils gathered round the maypole at Wooburn Infants' School in 1910. The children, clockwise from centre front, are George Whapshot, Nellie Barton, Eric Ryder, Nellie Poacher, Ivy Howard, Arch Muckley, Bella Wells, Arthur Wethered, Annie Chambers, John Hay, Esther Hawes, Ern Wootton, Nellie Mitchell, Jim Barnett, Millicent Stopps and Wally Wethered.

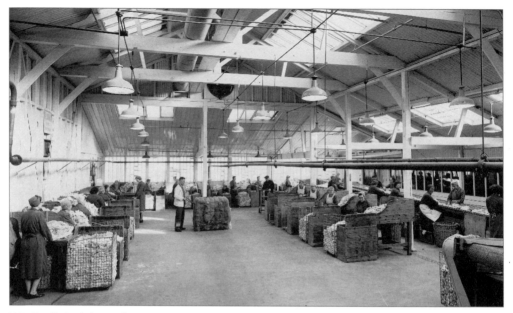

T.B. Ford's Snakeley Mill in Boundary Road, Loudwater, produced high quality blotting paper for many years. In the 'rag house', shown here in the 1940s, rags from many sources were sorted for paper production.

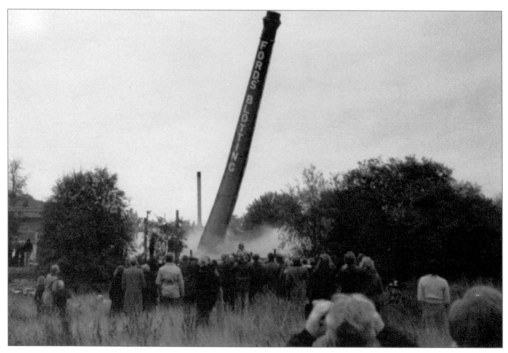

Going, going, gone! Excited crowds watching the demolition of the chimney at Ford's Mill in October 1976, after the closure of the premises. The mill was one of the last of many that once operated in the Wye Valley.

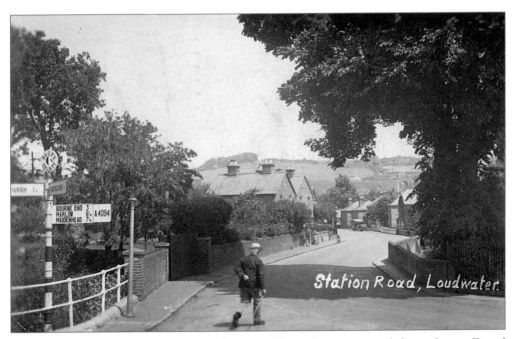

Station Road, Loudwater, as it appeared in the 1930s. This bridge was too weak for modern traffic and was replaced in 1995.

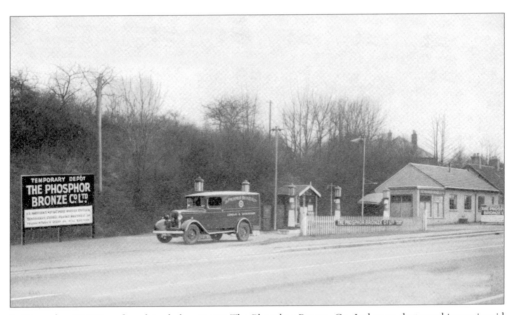

In December 1940 two foundries belonging to The Phosphor Bronze Co. Ltd were destroyed in an air raid on London, leaving production to the company's two foundries in Birmingham. The premises shown here, on the A40 at White Hill, Wooburn Moor, were leased in 1941 from Captain Harrison and his sons while they were on war service. The buildings were used for the storage, distribution and sale of non-ferrous metals from the Birmingham works, before closing in the late 1950s. After the war the Harrison family continued to run their filling station and a motorcycle agency on the site.

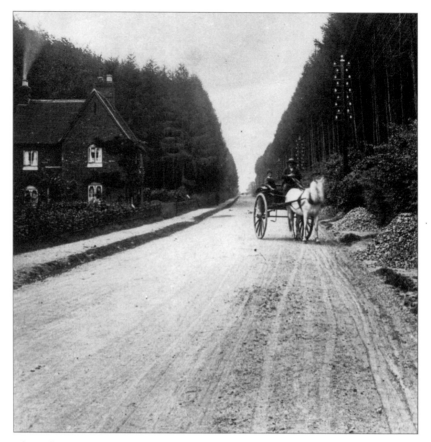

The White Hill cutting, shown here in 1895, is located between Holtspur and Wooburn Moor on the A40. It was constructed, together with an embankment, in the 1820s to Thomas Telford's design and replaced two separate steep roads, one for uphill and one for downhill traffic. Newspaper reports at the time described the work as being of 'extreme magnitude'.

ACKNOWLEDGEMENTS

The successful making of this book is due to the enthusiastic efforts of the five co-authors who form the archive sub-committee of the Beaconsfield and District Historical Society. They have selected pictures from the Society's archives and are also greatly indebted to the many local residents who have generously lent or given to the Society a wide range of additional pictures. These have added much to the scope and interest of the book. Thanks are also due to Ronald Goodearl for permission to use his photographs of Princess Alexandra opening the new school in Maxwell Road and of the school nativity play, and to Cyril Roberts for permission to use his photograph of the Doom at Penn.

BRITAIN IN OLD PHOTOGRAPHS

To order any of these titles please telephone our distributor, Littlehampton Book Services on 01903 7215
For a catalogue of these and our other titles please ring Regina Schinner on 01453 731114